Copyright © 2014 by Mary K. Hukill

All rights reserved. In accordance with the U.S. Copyright Act of 1976, the scanning, uploading, and electronic sharing of any part of this book without the permission of the publisher is unlawful piracy and theft of the Author's intellectual property. If you would like to use material from the Book (other than for preview purposes), prior written permission must be obtained by contacting the publisher, Mary K. Hukill, at Email: flowersbookseries@gmail.com.

Printed in the United States of America.

First Edition, Volume Two, 2014

Flowers Book Series
Email: flowersbookseries@gmail.com

Library of Congress

ISBN-13: 978-1495344244

ISBN-10: 149534424X

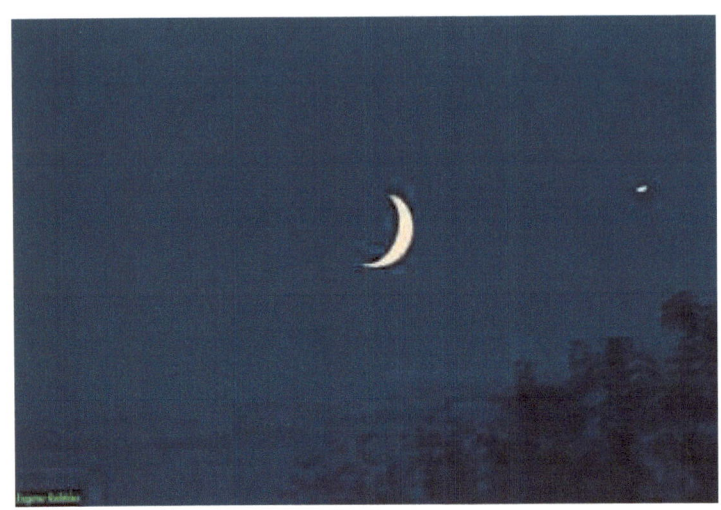
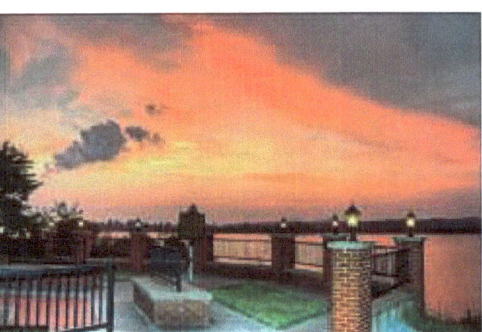

Buckle Up! Enjoy the ride…..travel along the "Country Back Roads"………..

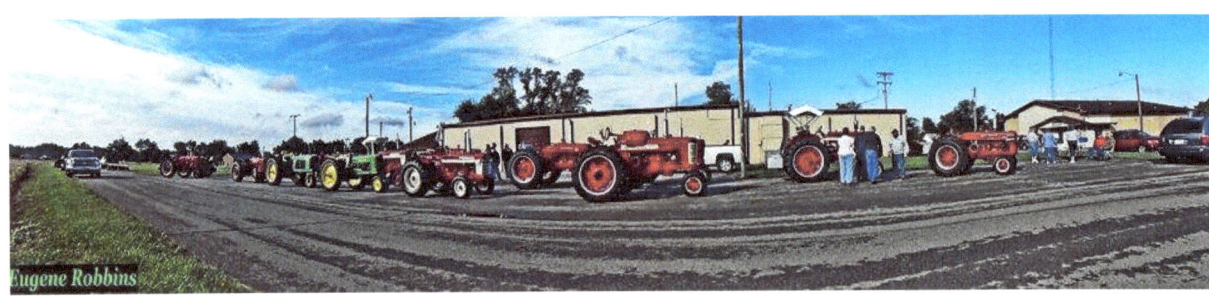

Happy 35th Anniversary to the American Community Garden Association in 2014.

American Community Garden Association

1777 East Broad Street

Columbus, Ohio 43203-2040

www.communitygarden.org

info@communitygarden.org

Phone: 1-614-645-1880

An amount from each Book SOLD goes to the American Community Garden Association to provide FUNDS to re-grant for cities and towns to start or augment Community Gardens.

Other Books in the "Country Back Roads" Series…..

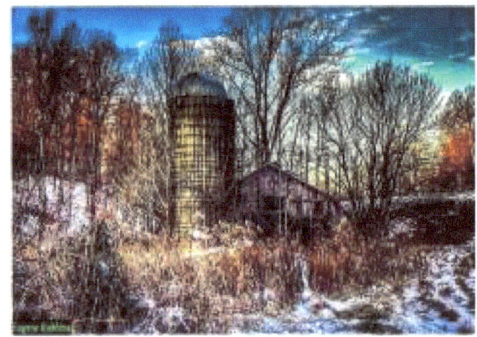

Country Back Roads

…of Western Kentucky and Southern Indiana

Compiled and Written by
Mary K. Hukill
Volume One

Pictures by Eugene Robbins
Travels by Eugene and Grace Robbins
of Lewisport, Kentucky

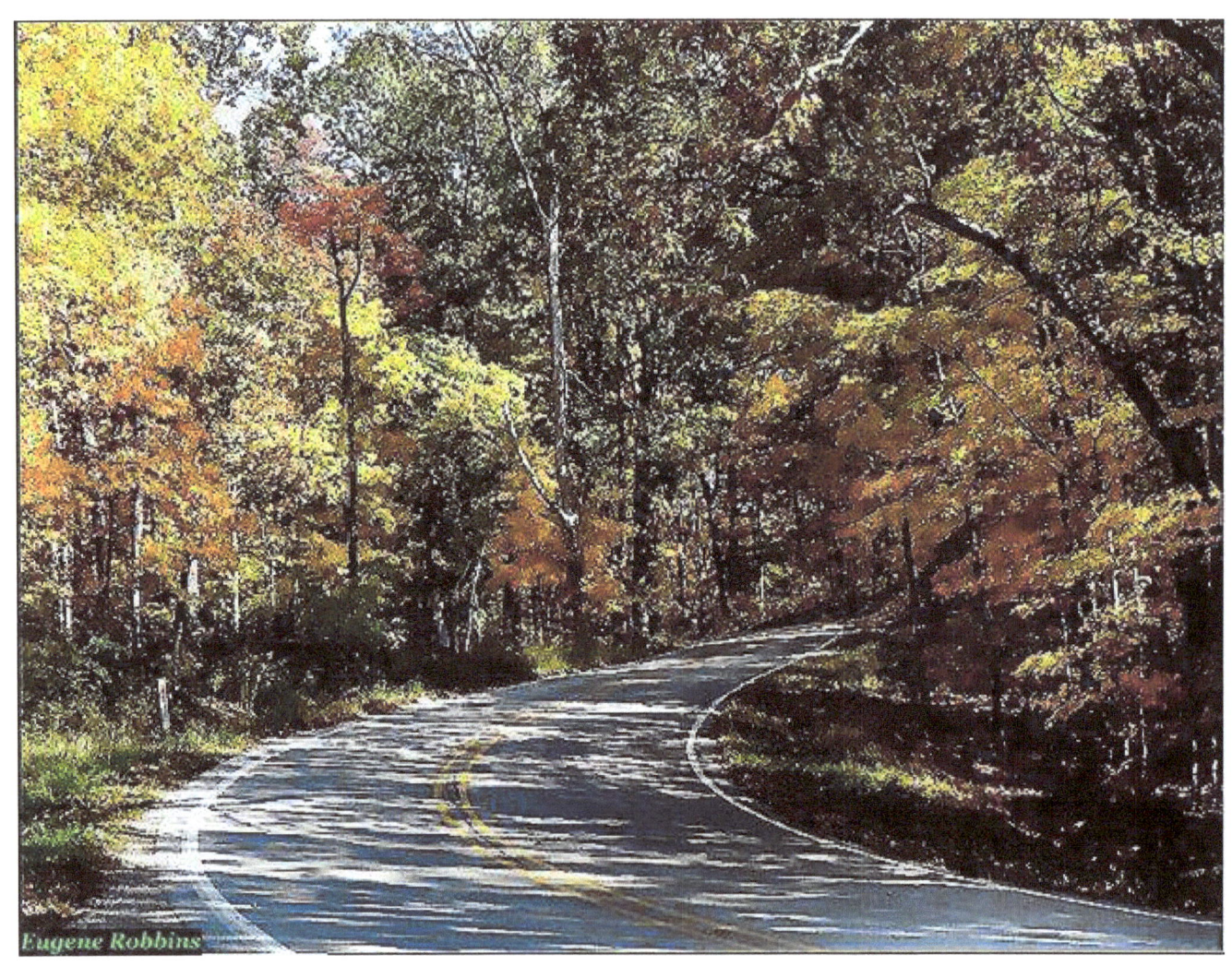

………… "Fall Colors along the Country Roads"………

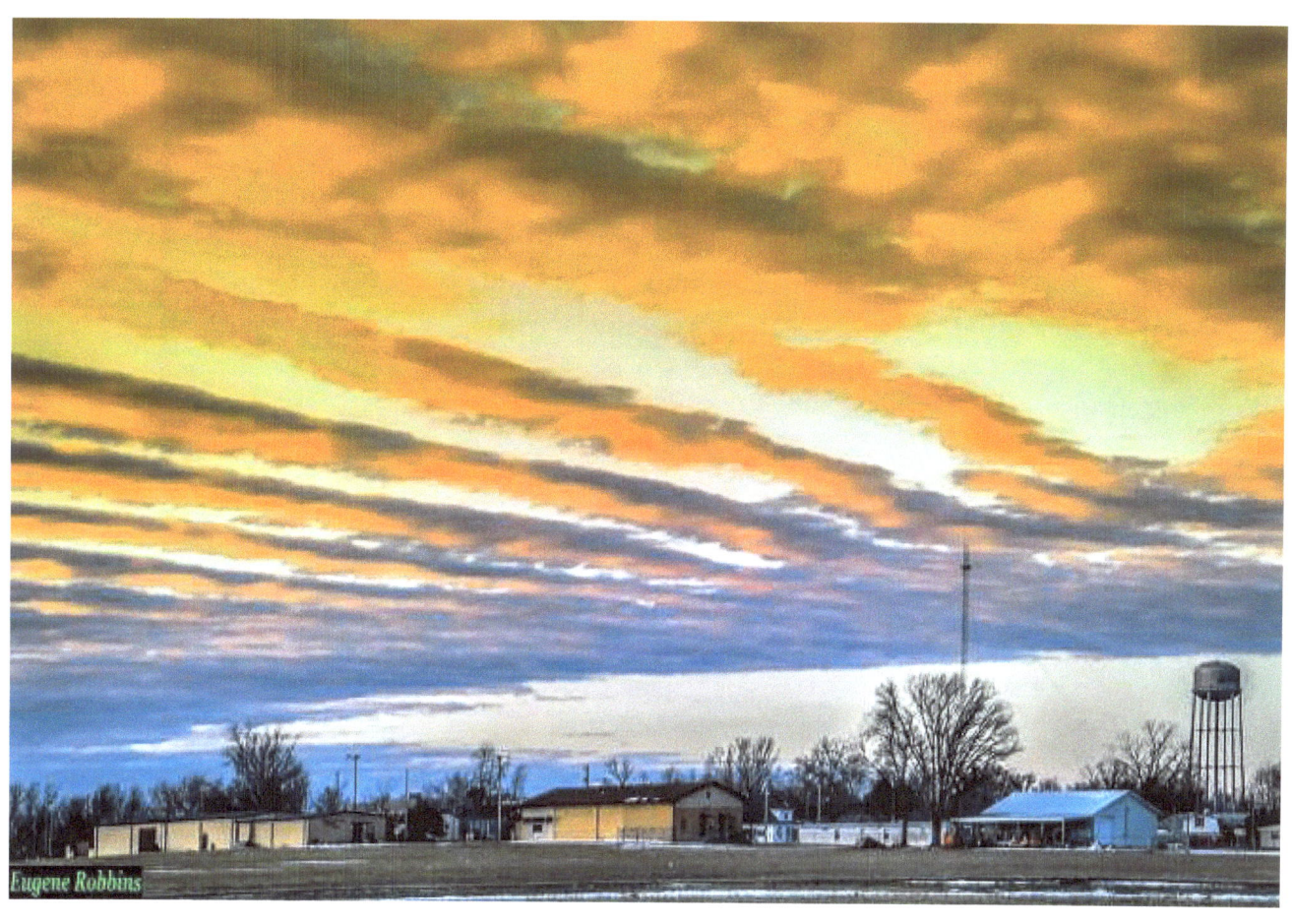

……."a shot of Lewisport, Kentucky, ……taken from Sand Hill Road

…… with the red streaks in the Sky"…….

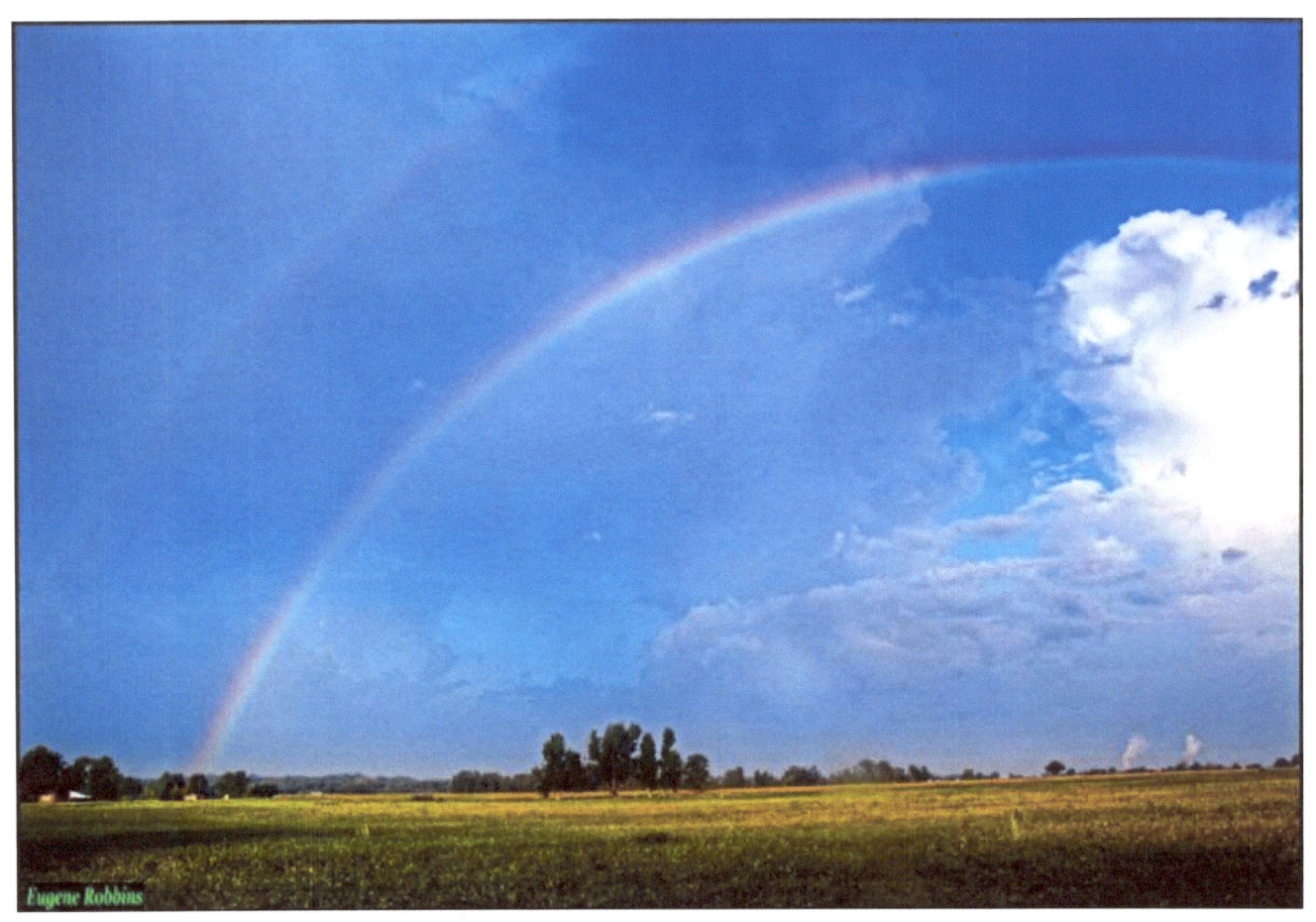

…………."what is on the other side of the Rainbow"……….

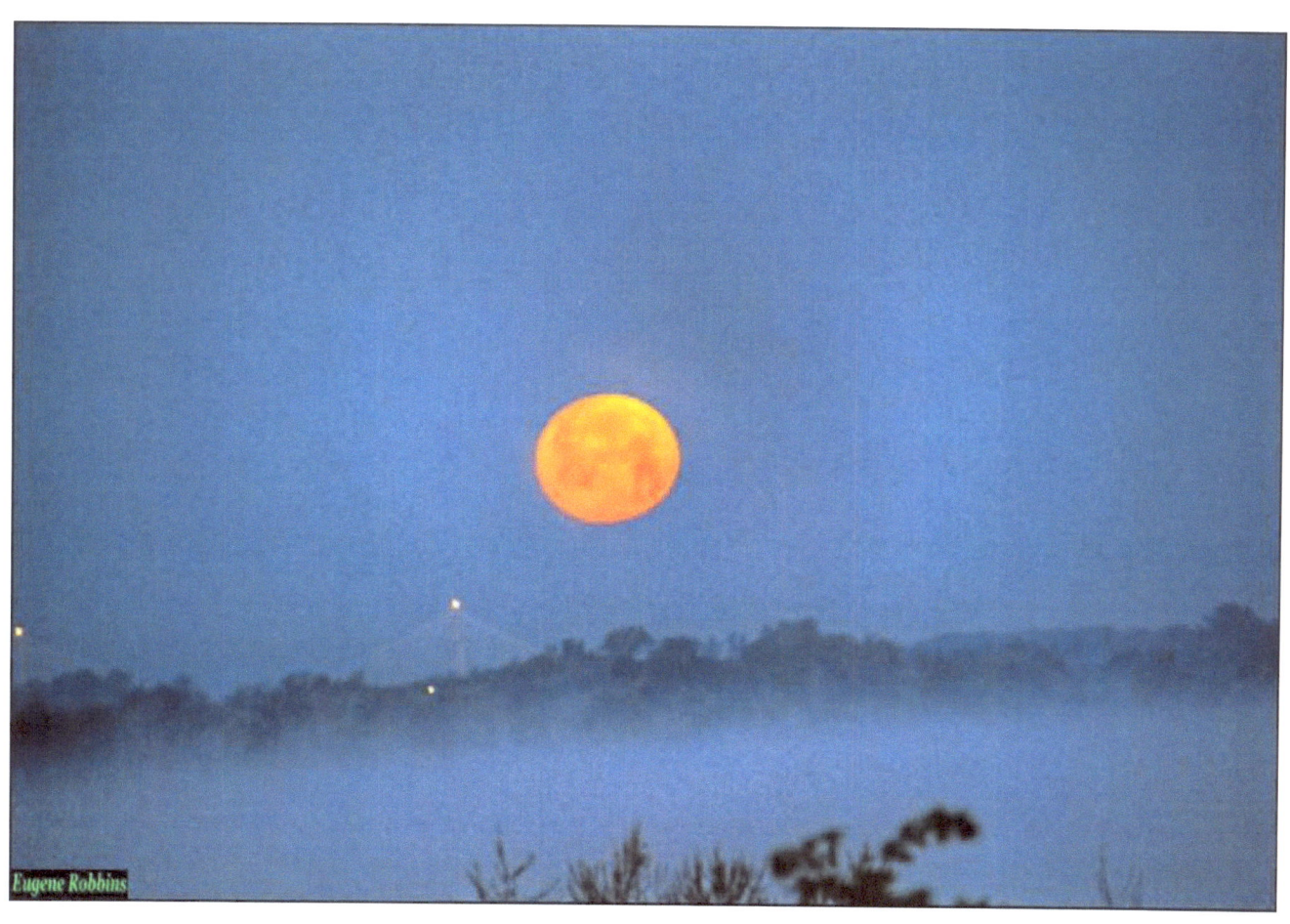

……."Full Moon one April Morning, Here's one shot along the Ohio River, with Fog,

and, the Rockport Bridge Piers just under the Moon"………

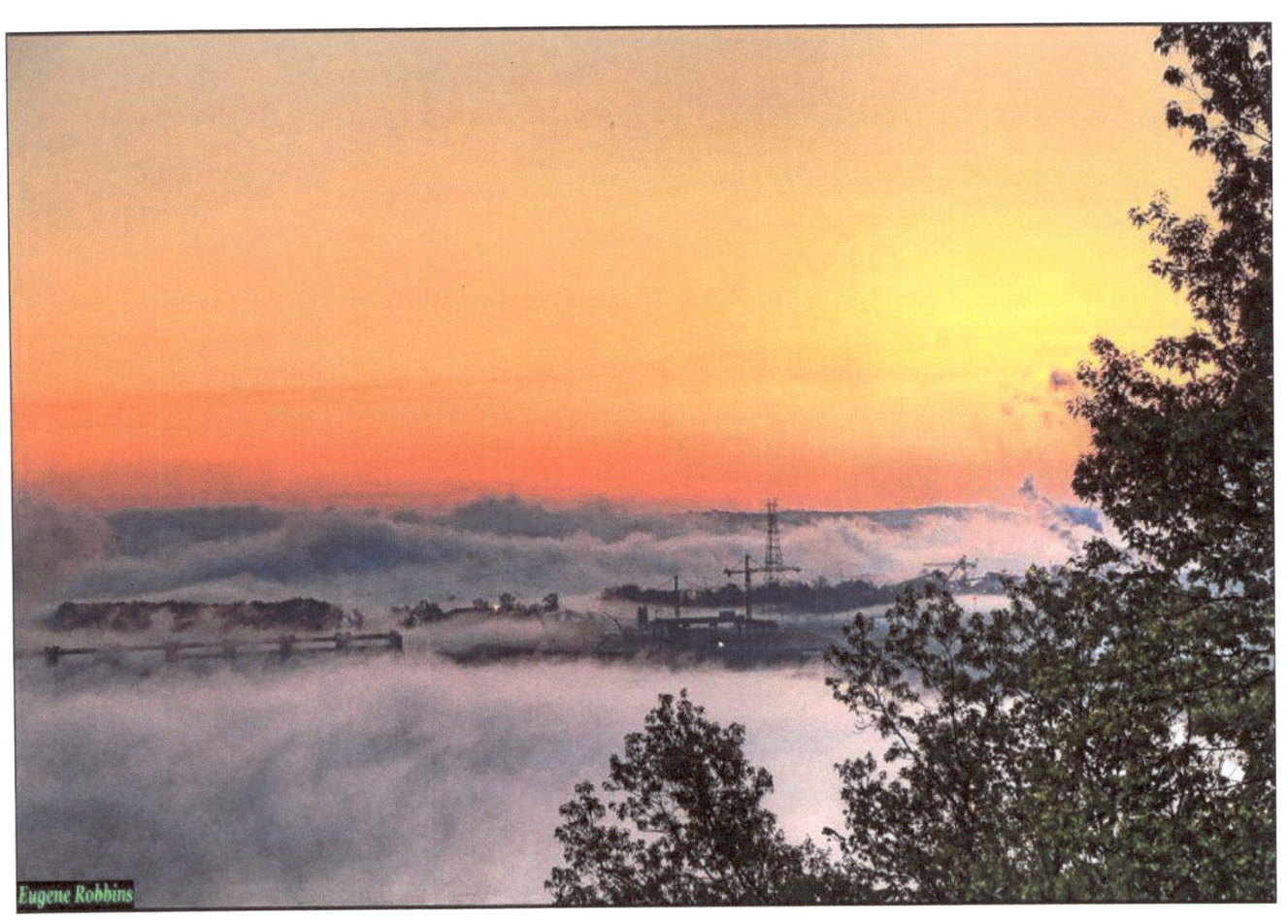

"Sunrise…….picture was shot up the Ohio River toward the Cannelton Locks and Dam from the look-out at Hawesville, Kentucky. The river, fog, awesome Sunrise, green trees, over a construction site all make for a pleasant sight".

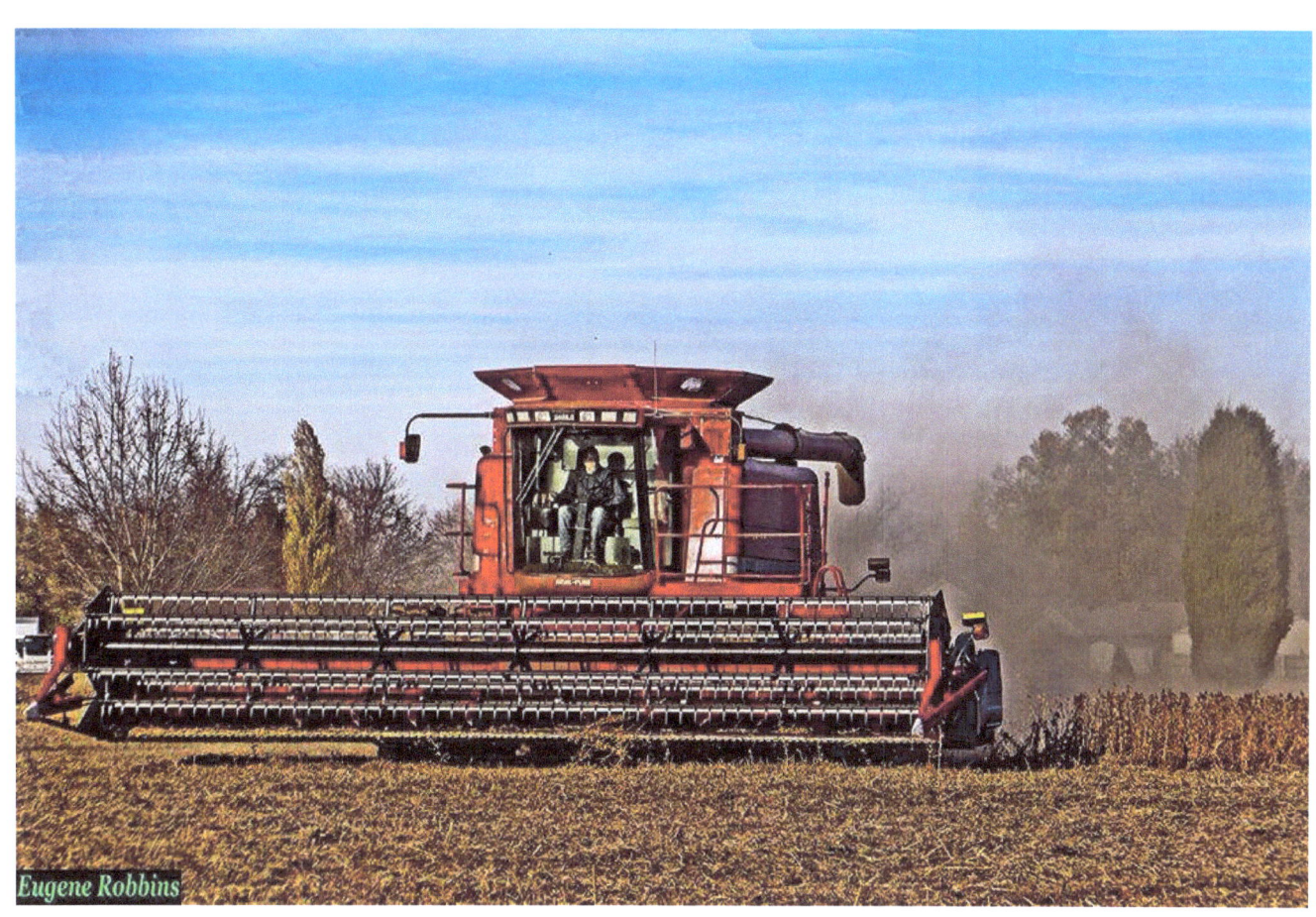

……."a picture of a Farmer combining the soybeans…..near Hancock Park"……..

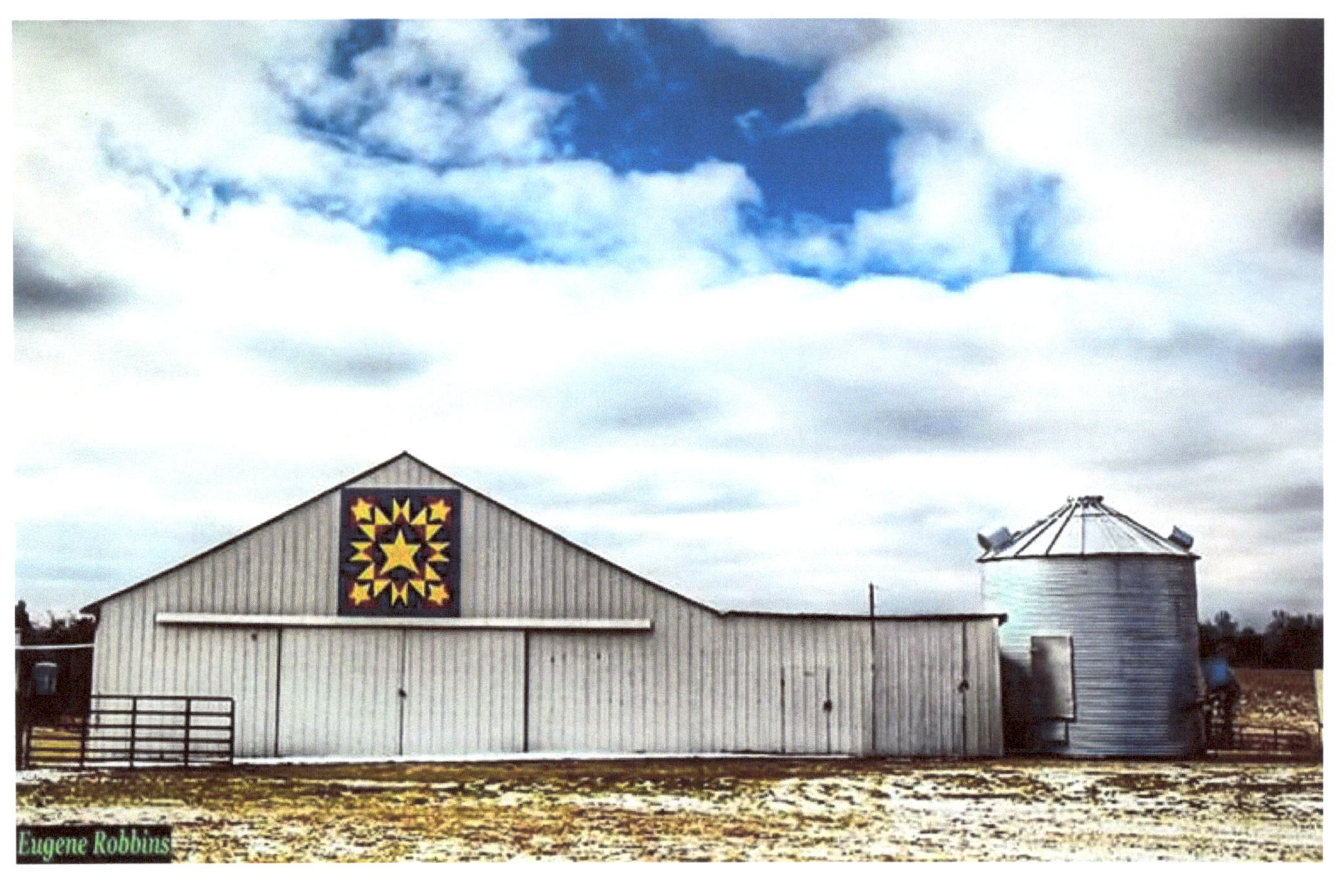

…………."a beautiful barn on the New Bethel Road (HWY 2779) in Breckenridge County"……….

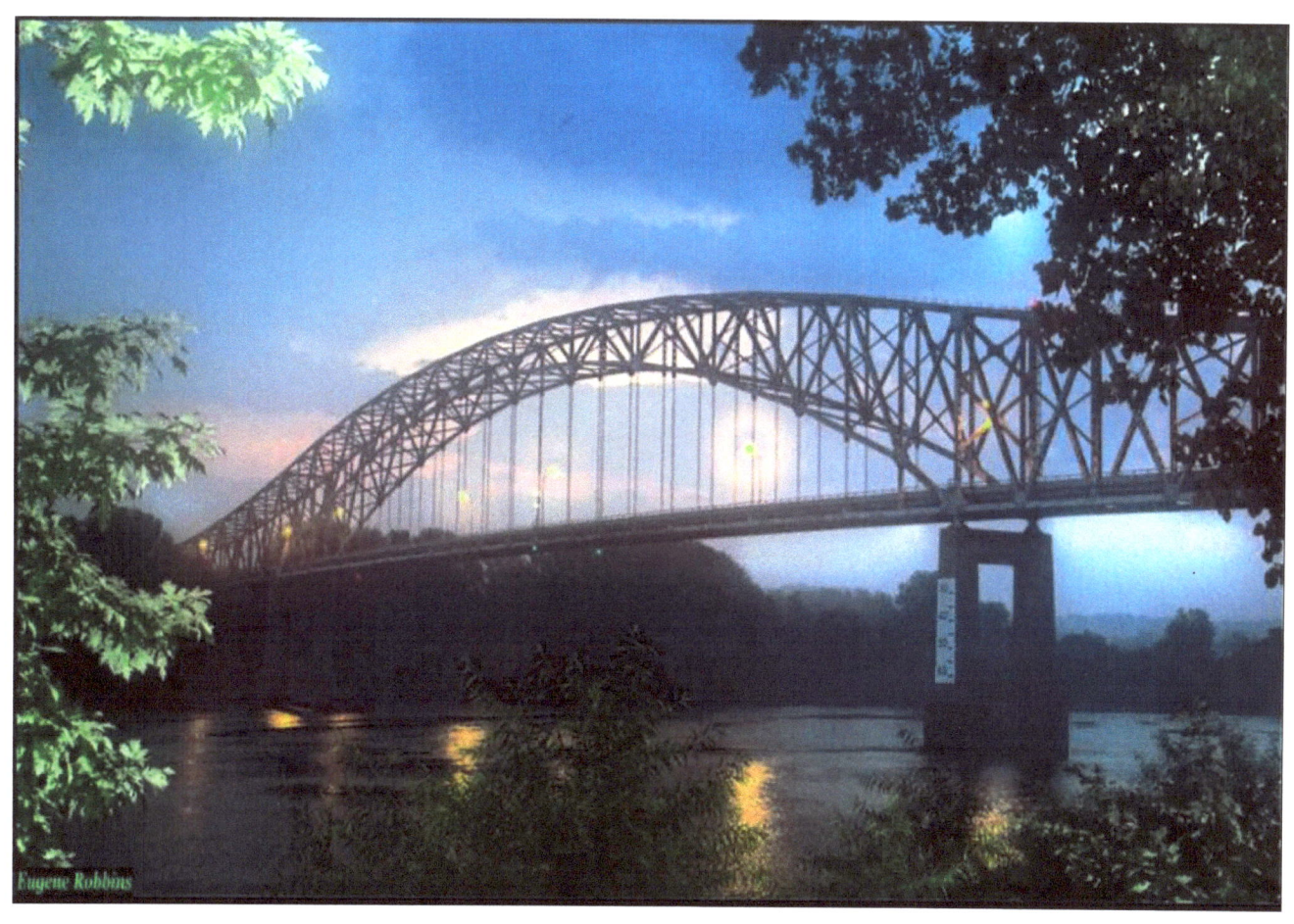

"Hawesville, Kentucky…..Here is a Sunrise shot of the Bob Cummings Lincoln Trail Bridge at Hawesville after some fog lifted at 5:45pm in the morning".

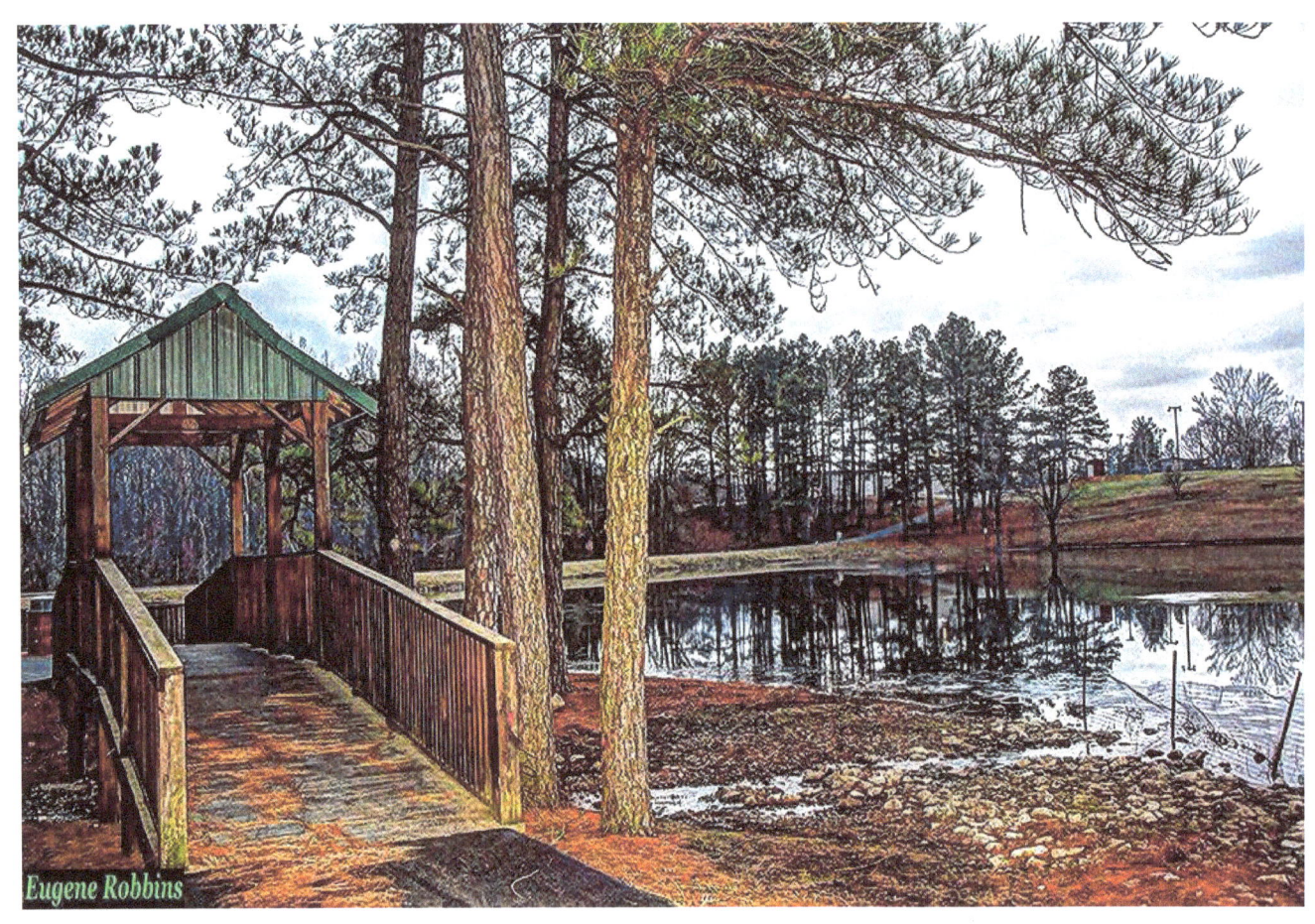

....."a Bridge on the walking trail at Vastwood Park"........

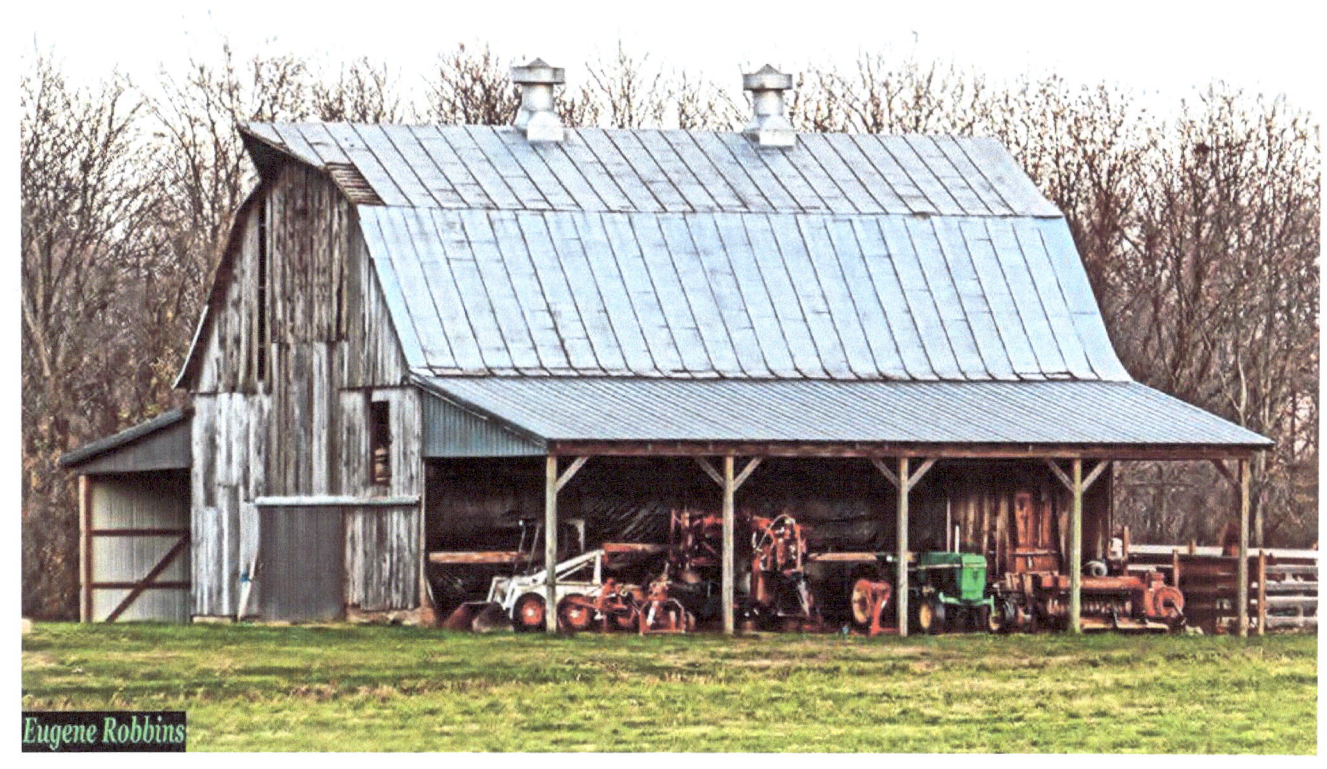

………"a picturesque Old Barn west of Hawesville, Kentucky, on US 60"………

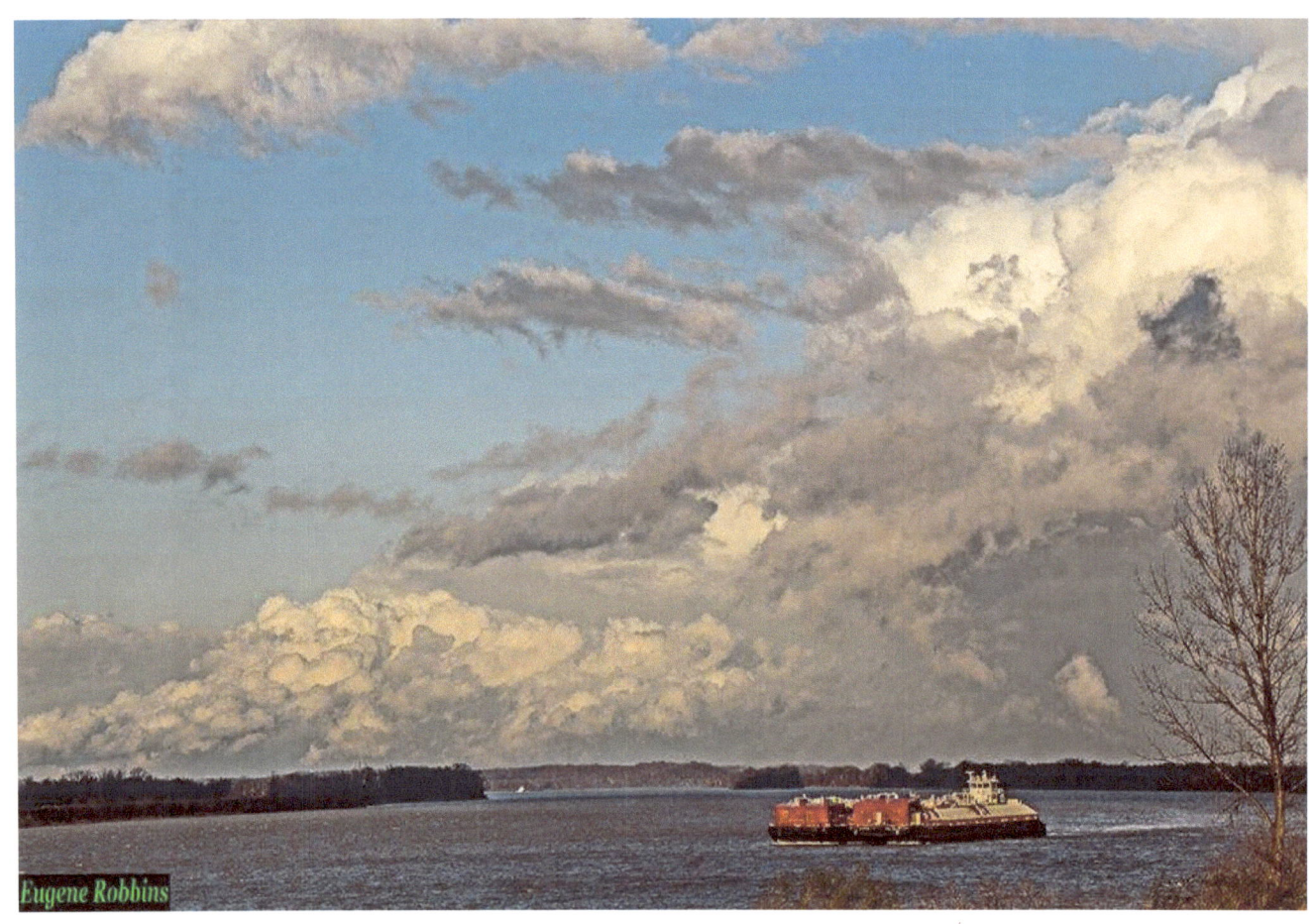

………."This was looking up the Ohio River"………..

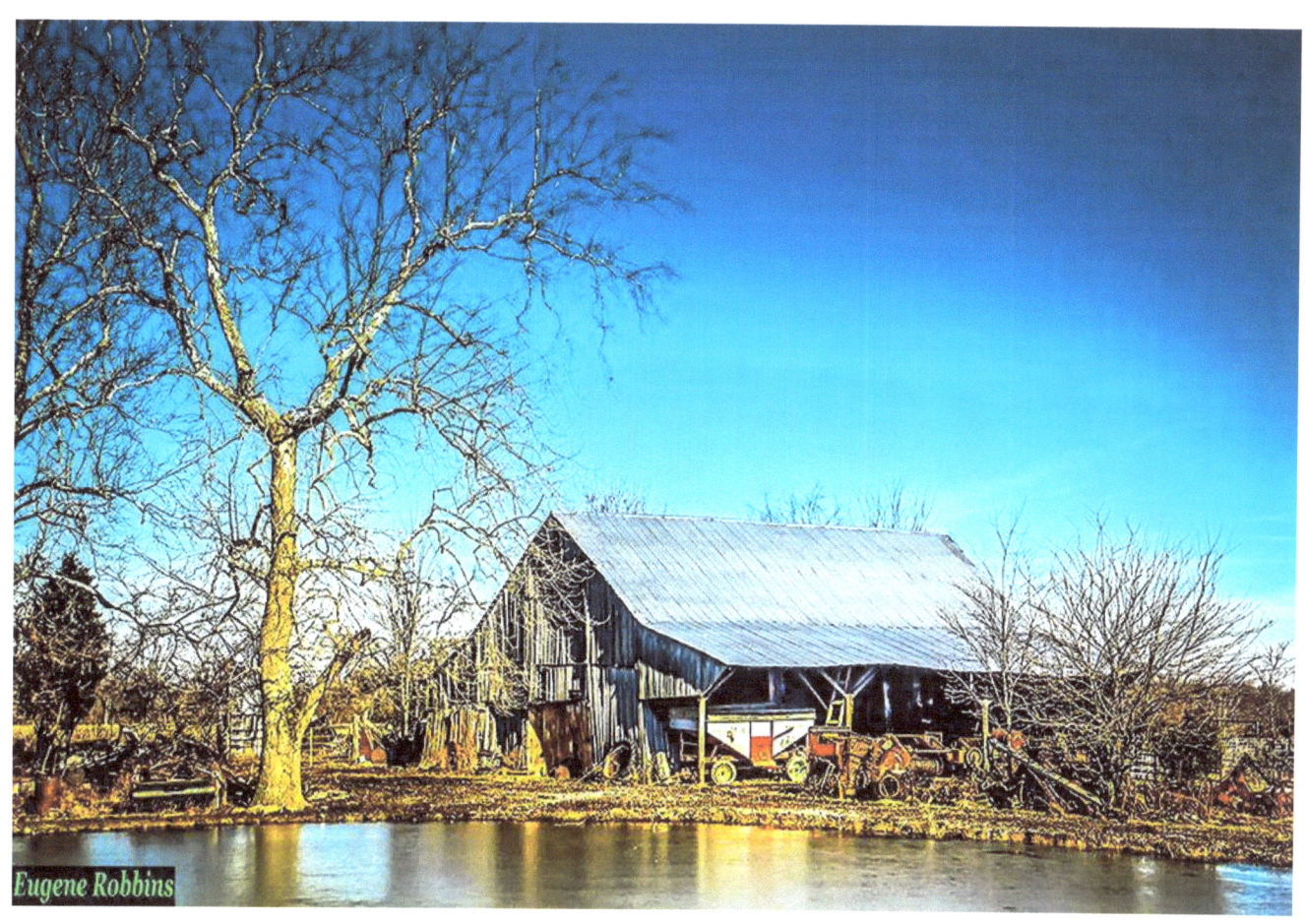

……."I love Sycamore Trees in the fall of the year…….

……. Having the blue sky, pond and barn really adds to this one"…………

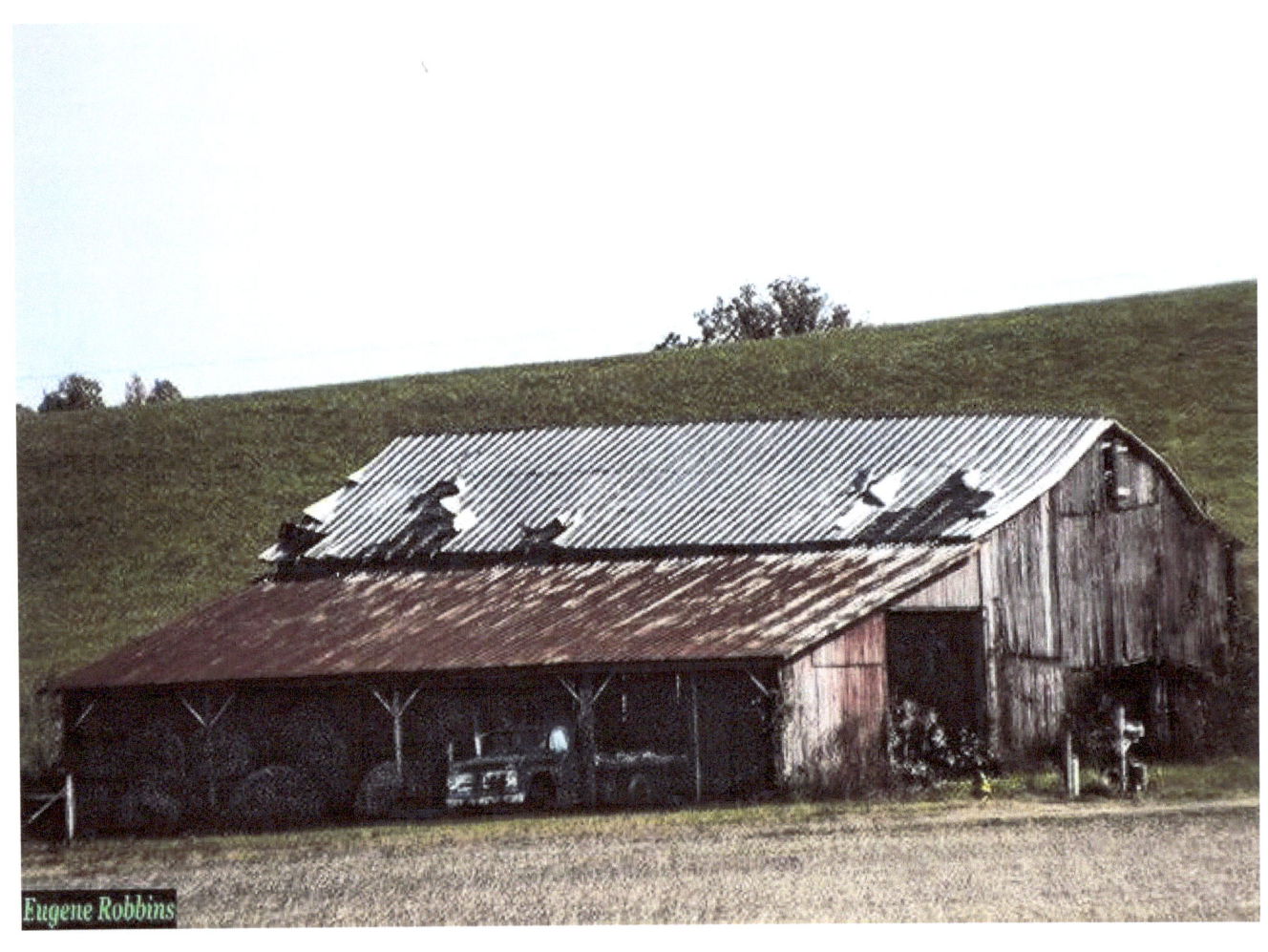

"This is south of Lewispark, Kentucky, on the Poplar Grove Road"………..

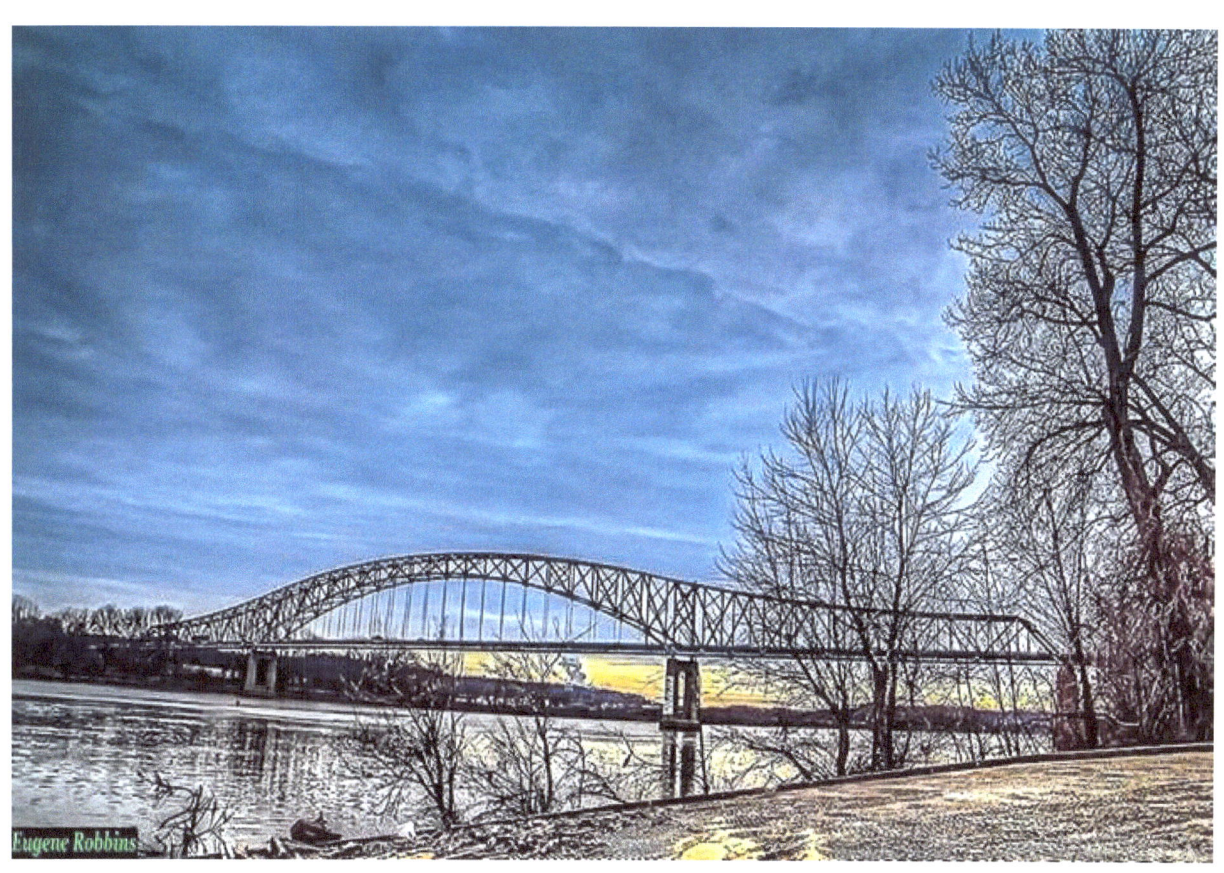

" A picturesque Sunrise at the Boat Ramp in Hawesville, Kentuck".

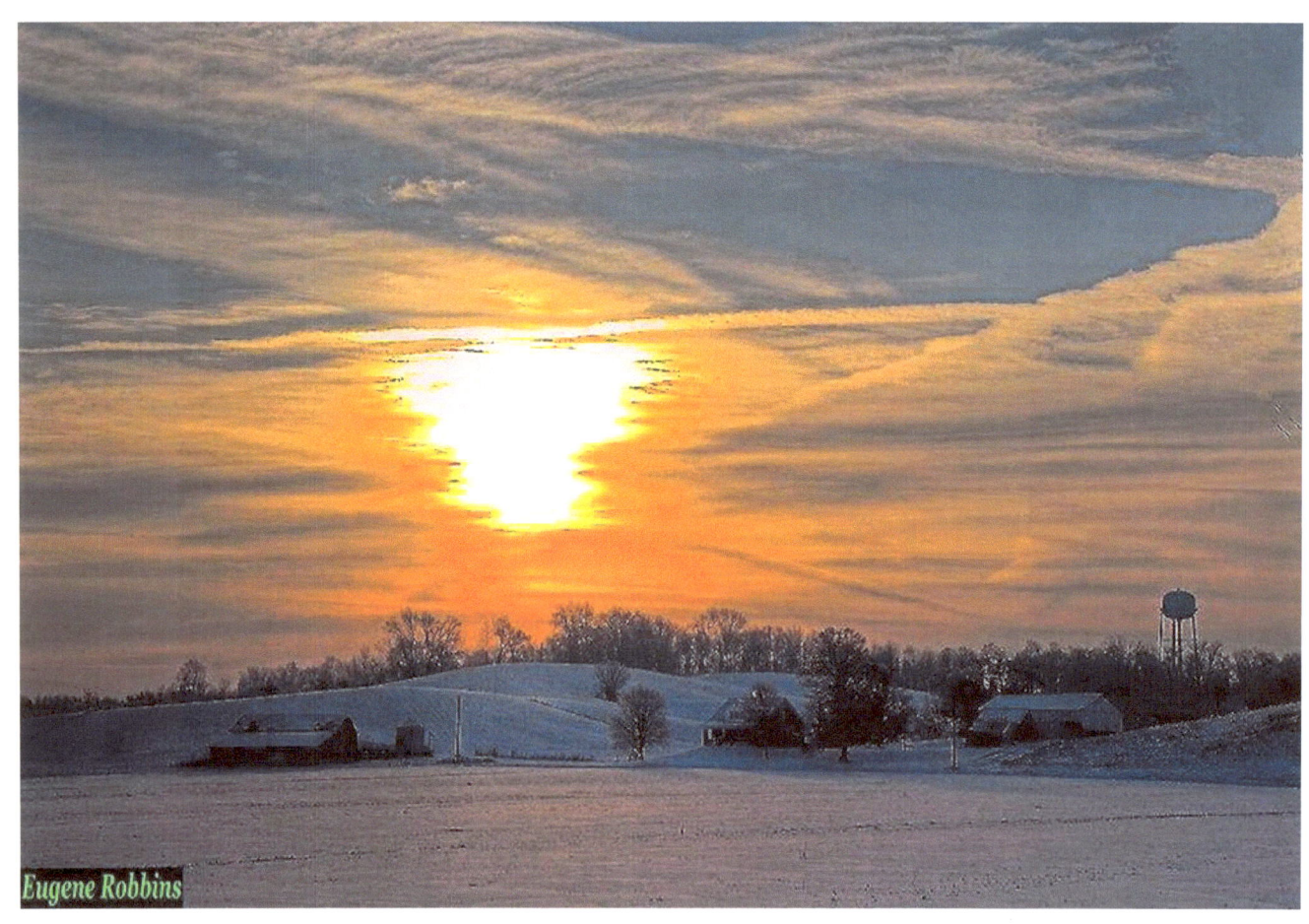

……."a Snow scene south of Lewisport, Kentucky"…………

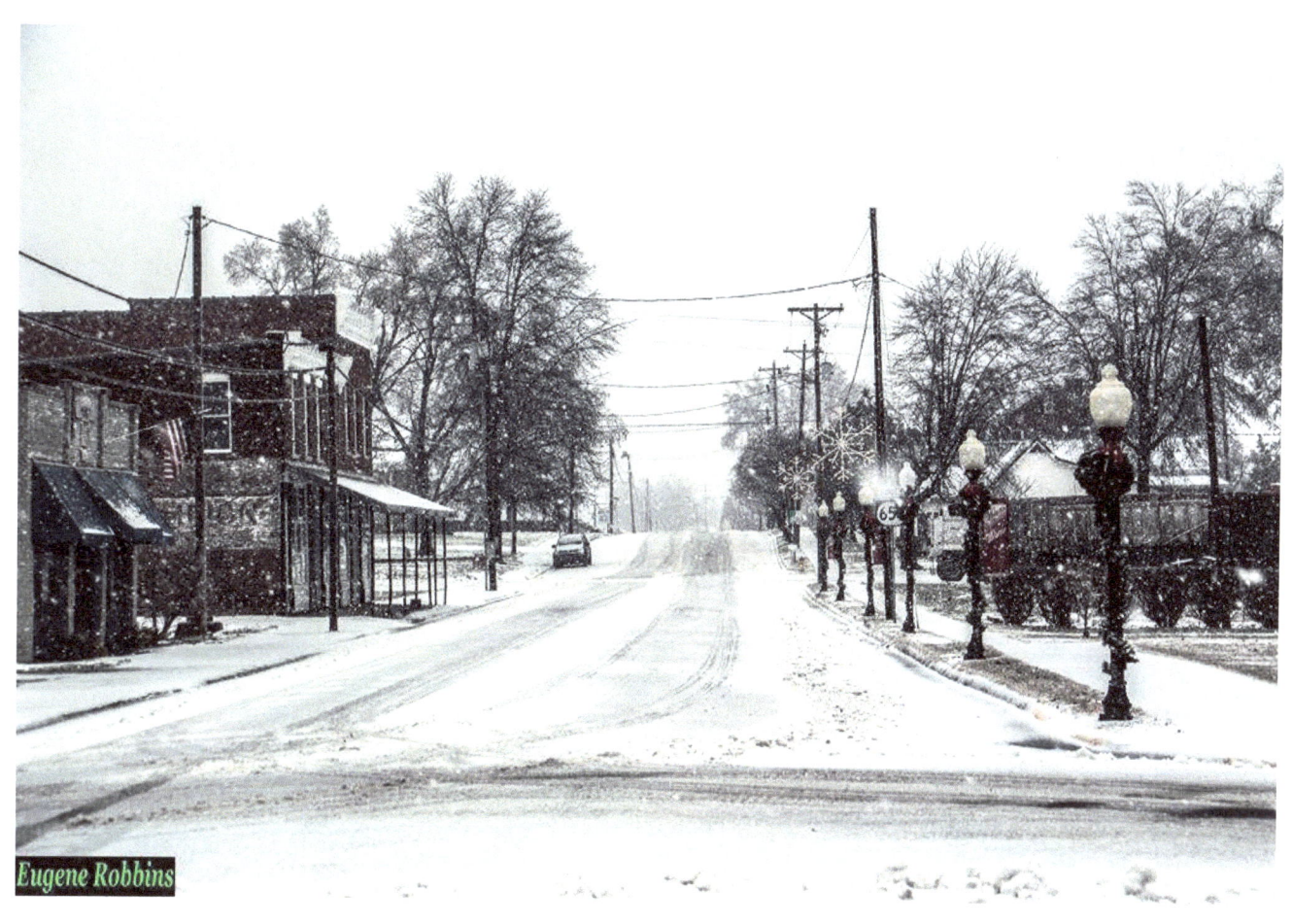

……."looks like a Postcard……Downtown Lewisport, Kentucky, at the Holiday Season"…..

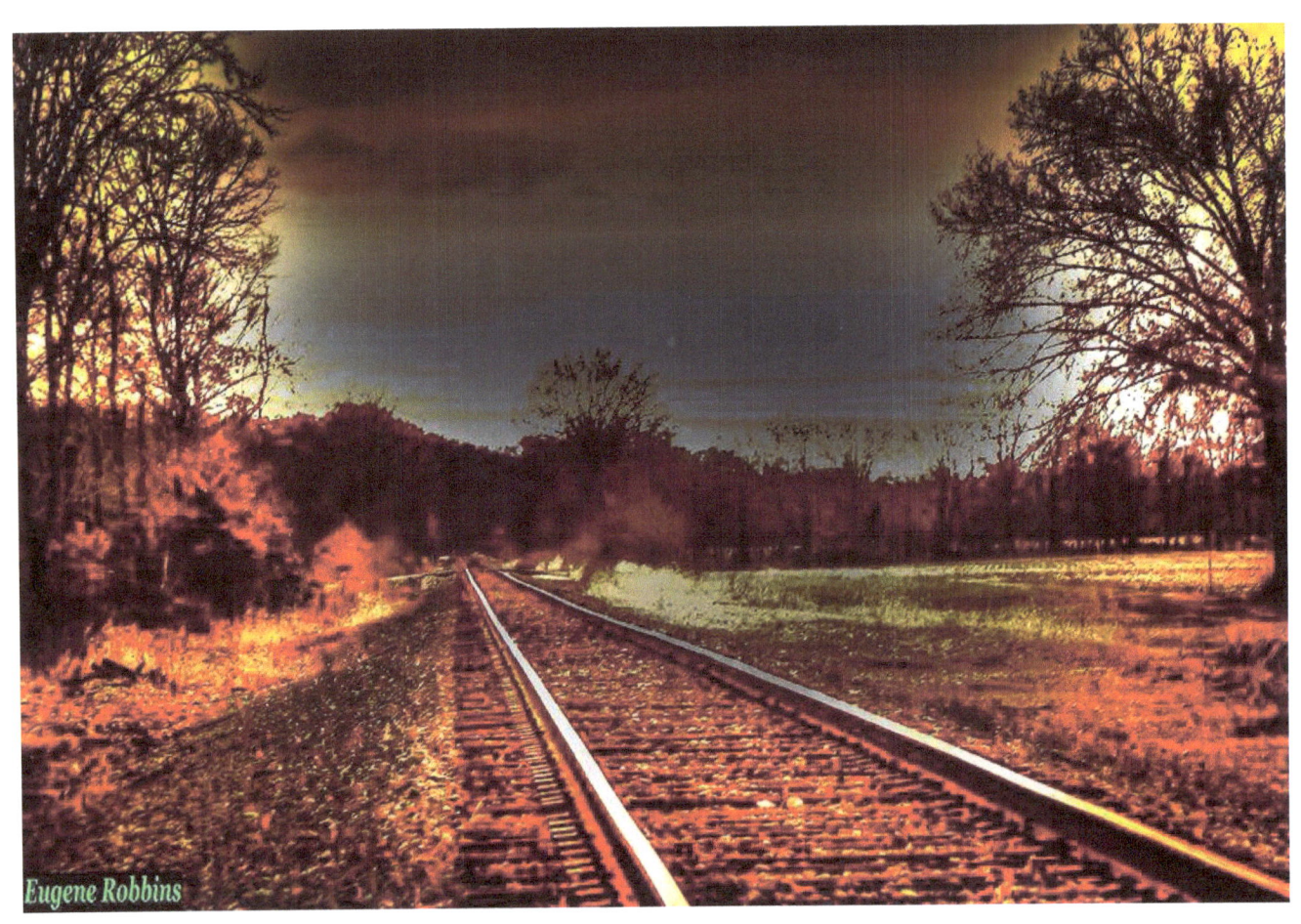

" A Sunset.

This picture was shot west of Lewisport, Kentucky, on Waitman Station Loop".

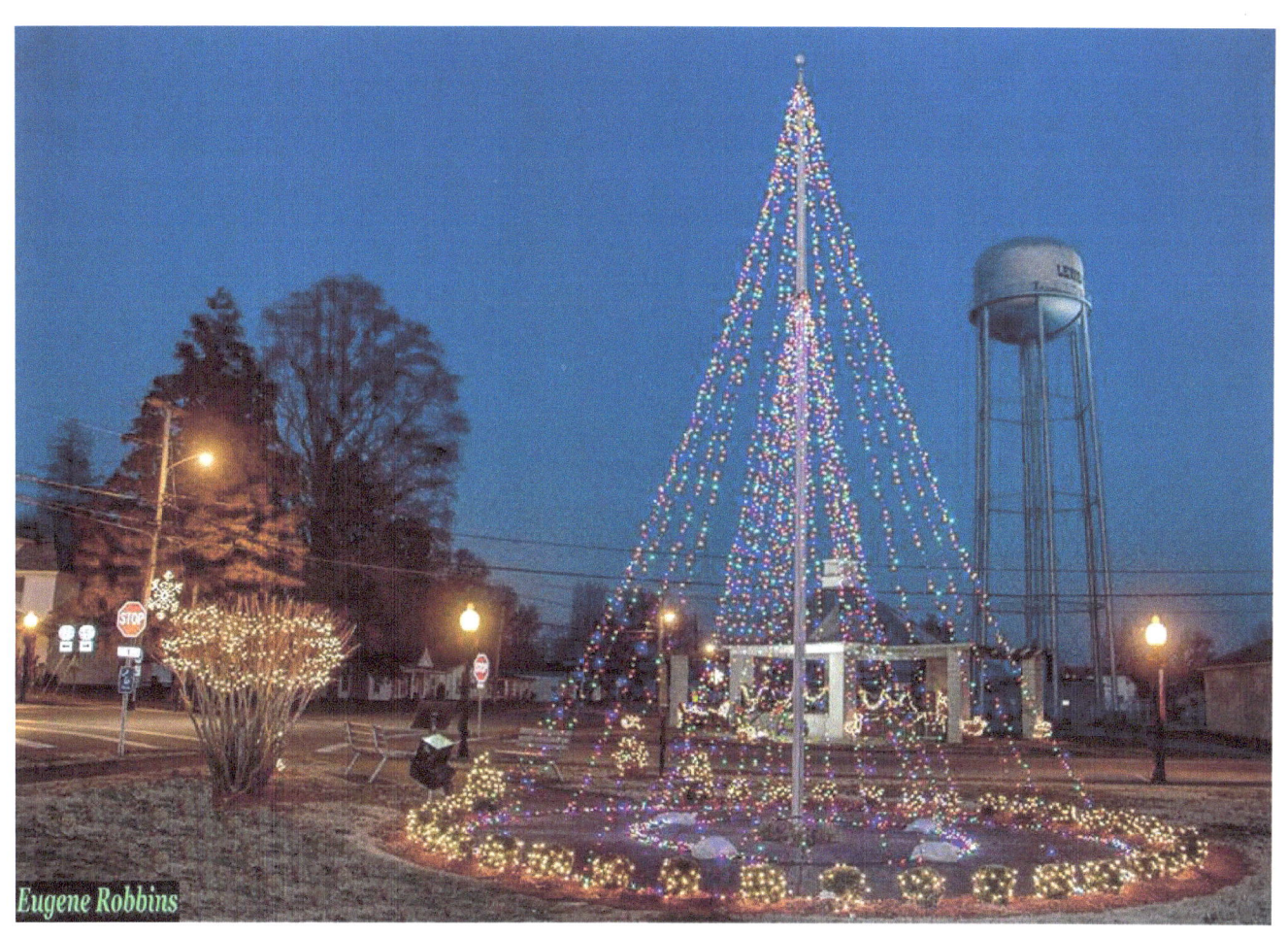

………."Downtown Lewisport, Kentucky, at the Holiday Season"………

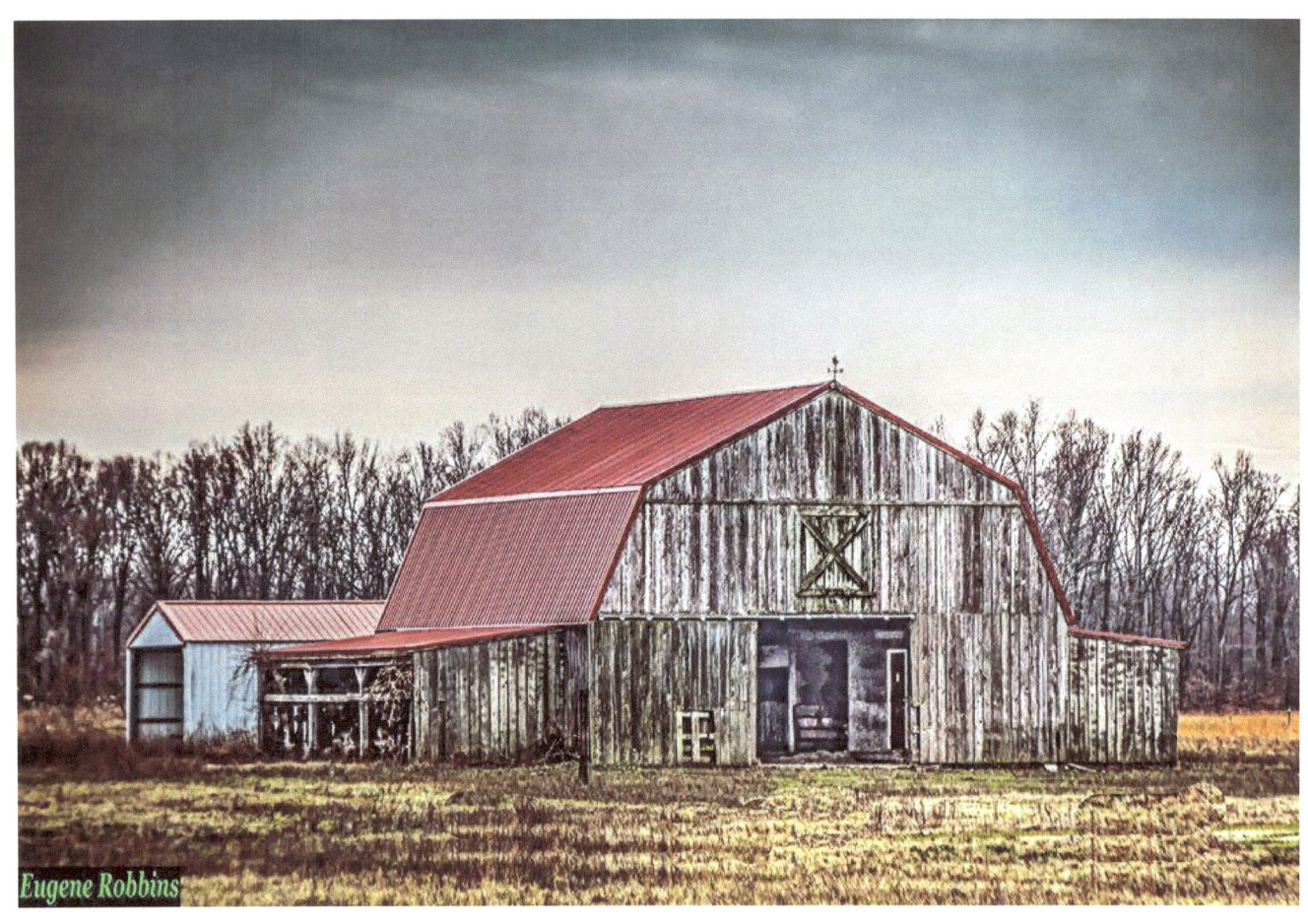

"This was south of Lewisport, Kentucky on HWY 661 before the Snow"………..

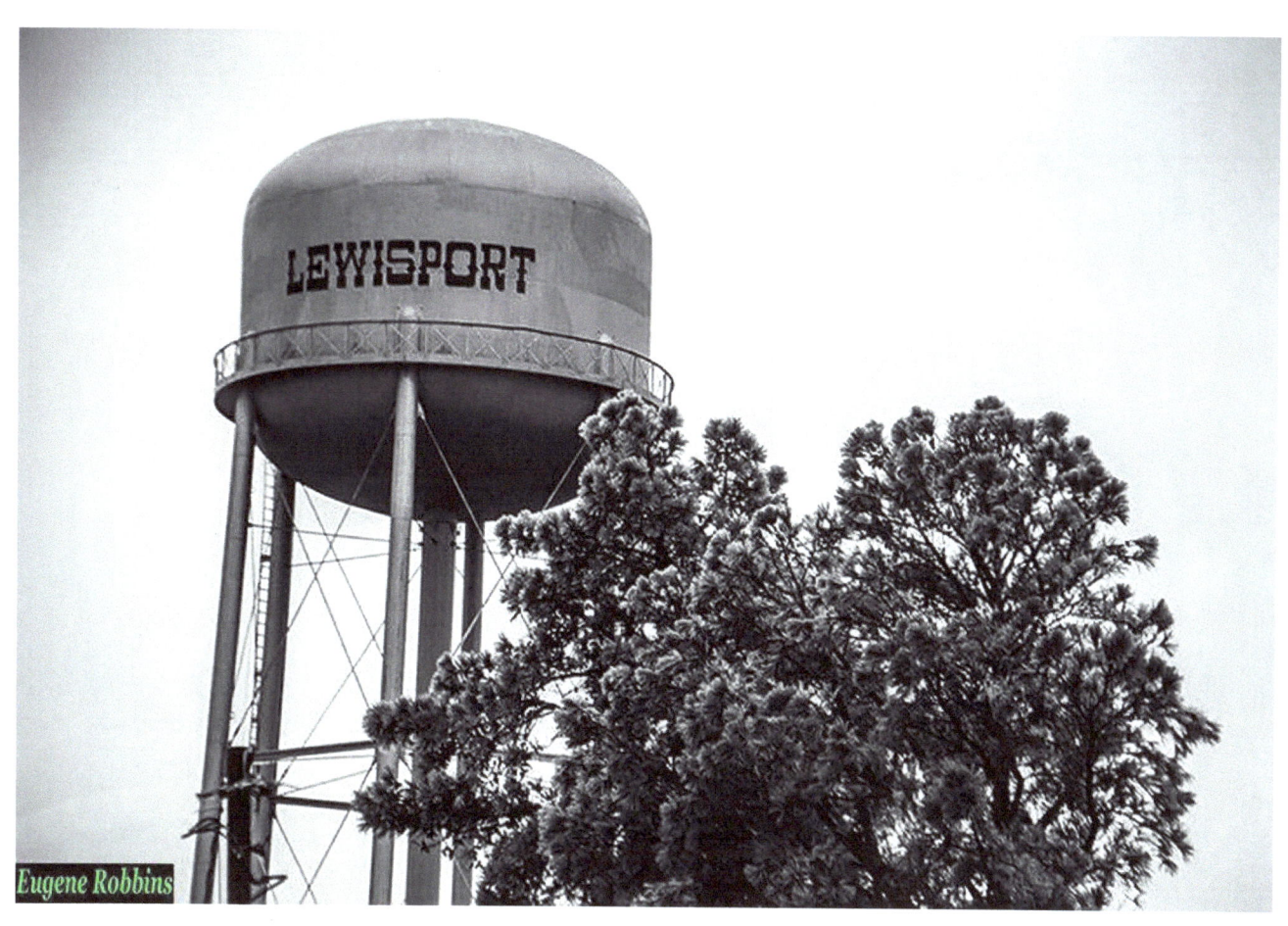

……"after a Snow and Ice Storm……in Lewisport, Kentucky"…………

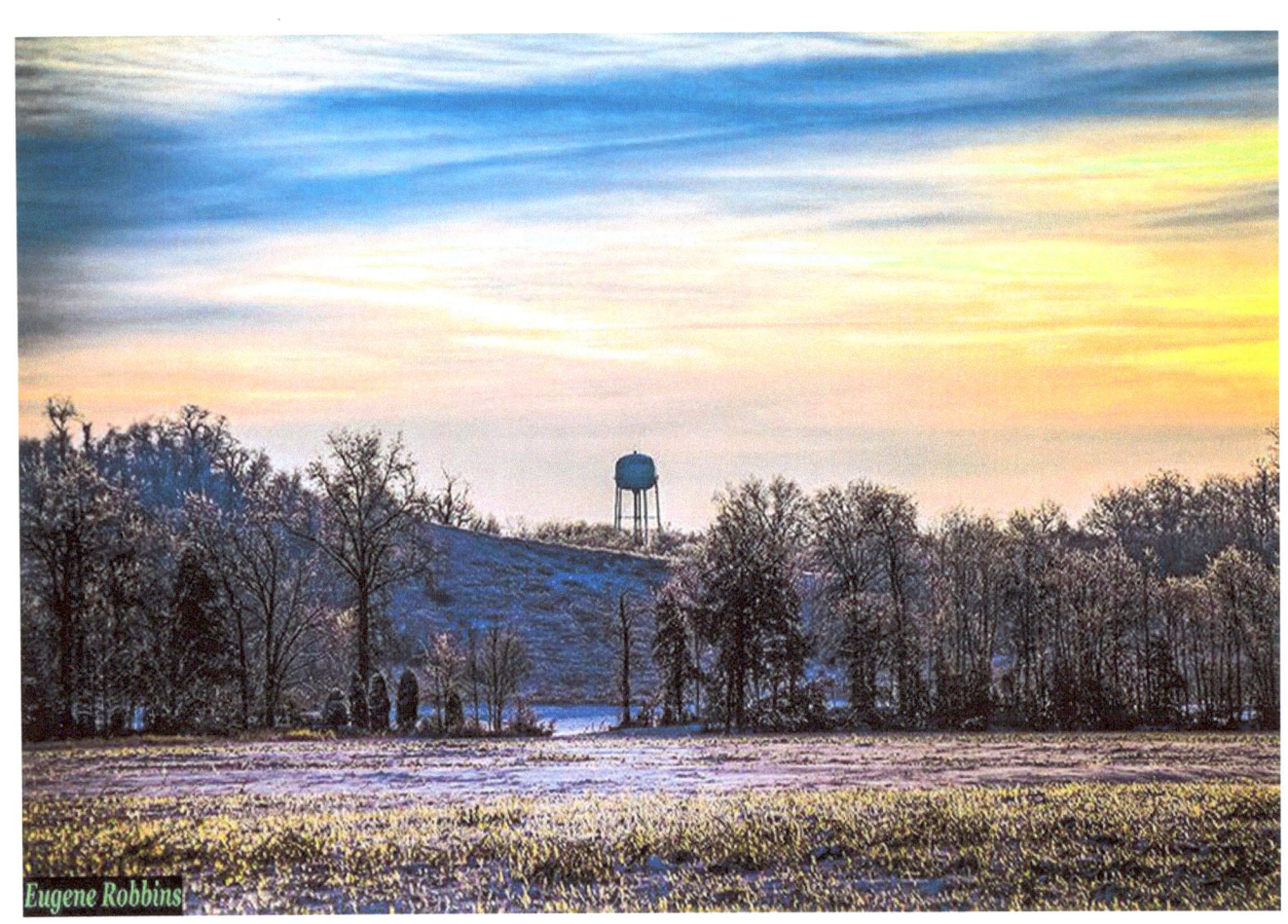

……"beautiful Sunrise this morning"…….

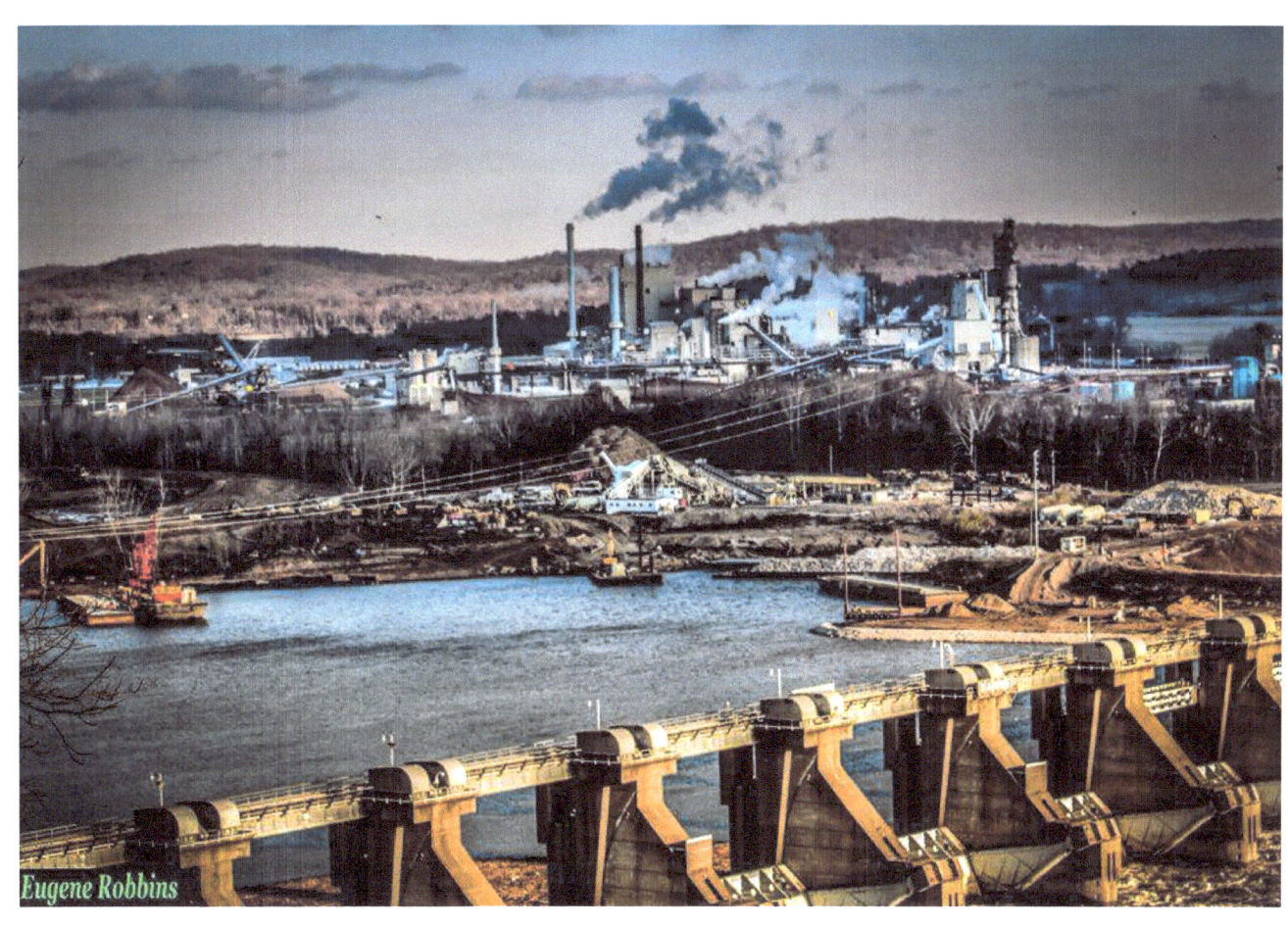

............"view of the Dam and Paper Mills. This one is shot across the Ohio River at Eagle's Bluff Park and Overlook"...................

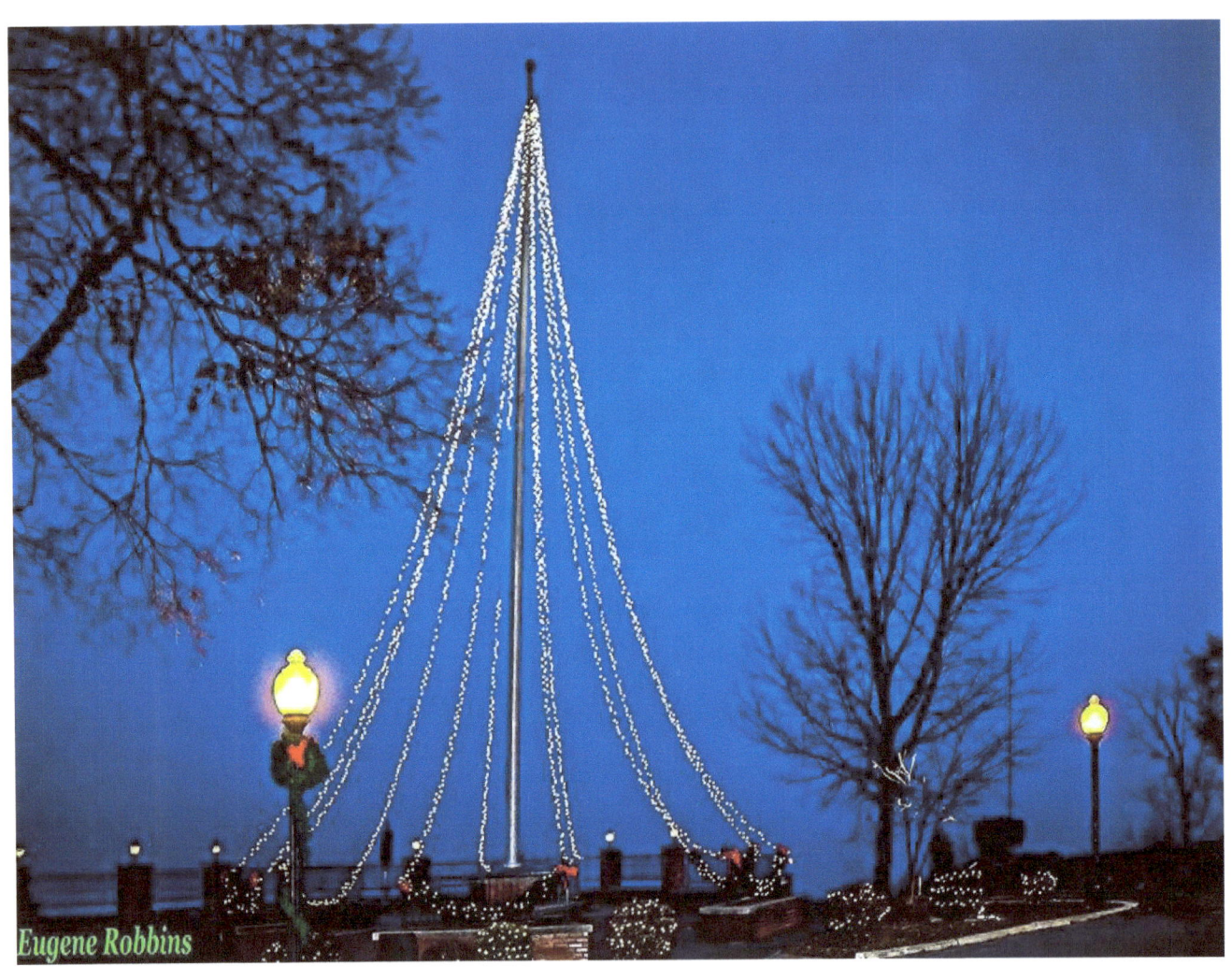

…………"on the way to the Coffee Shop, I went Downtown Lewisport, Kentucky,

had my Camera with me, and took this Holiday picture"……..

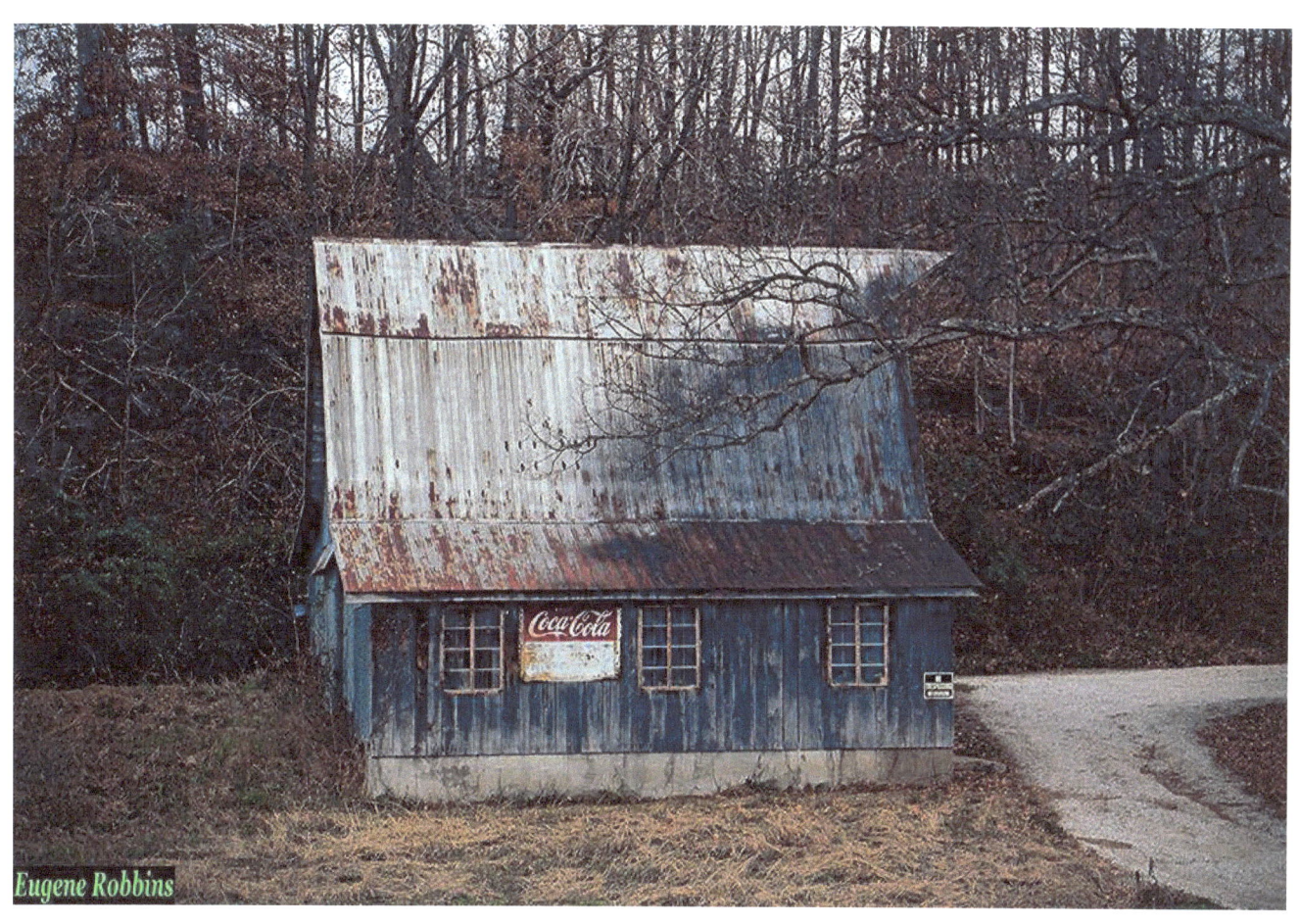

………."a barn this side of Cloverport, Kentucky, on US 60 that I have waited all Summer for the Leaves to fall so you can see the barn"……..

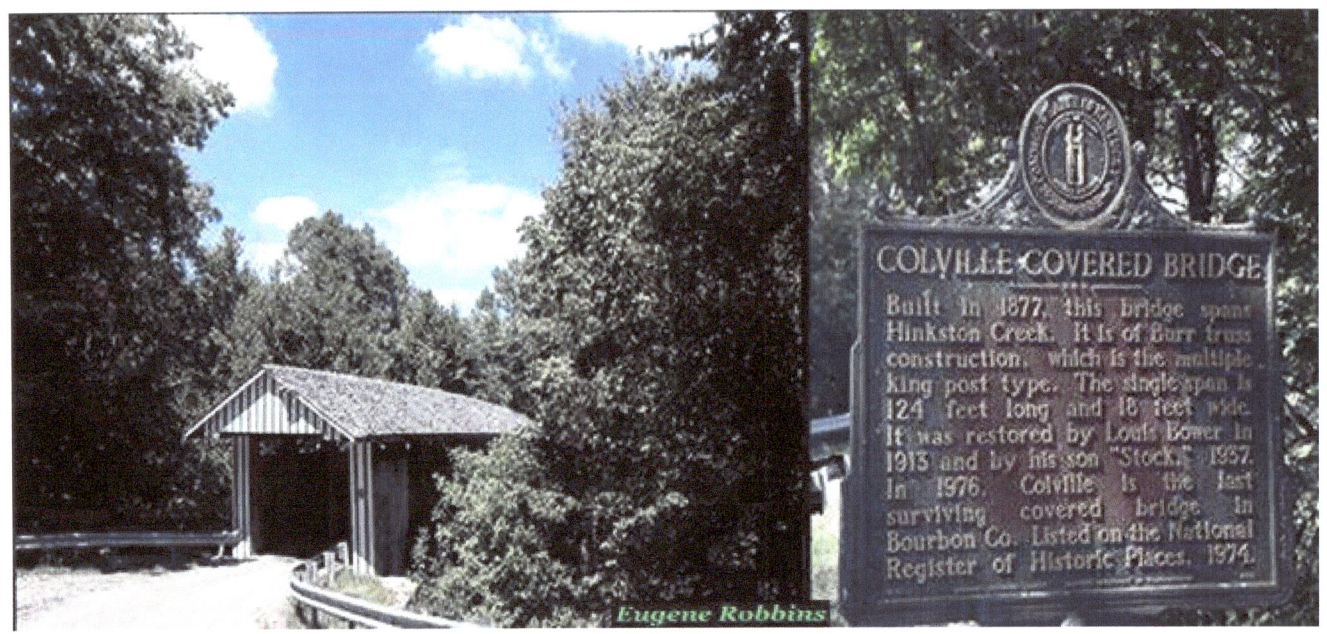

"Paris, Kentucky…….the Colville Covered Bridge on Colville Road just out of town. This one is still open to Traffic, there are only about 13 of these in Kentucky".

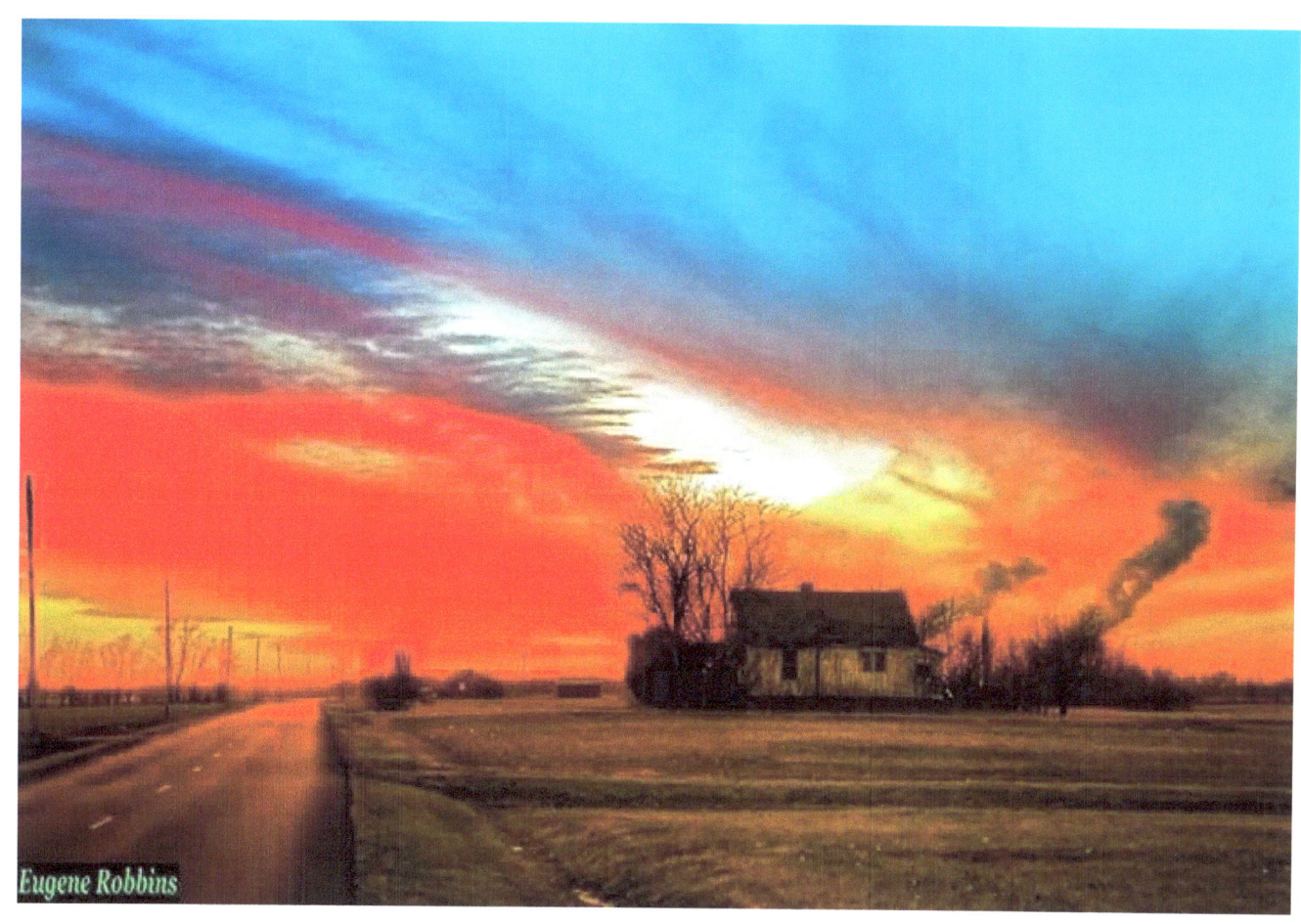

….."a Sunset"……

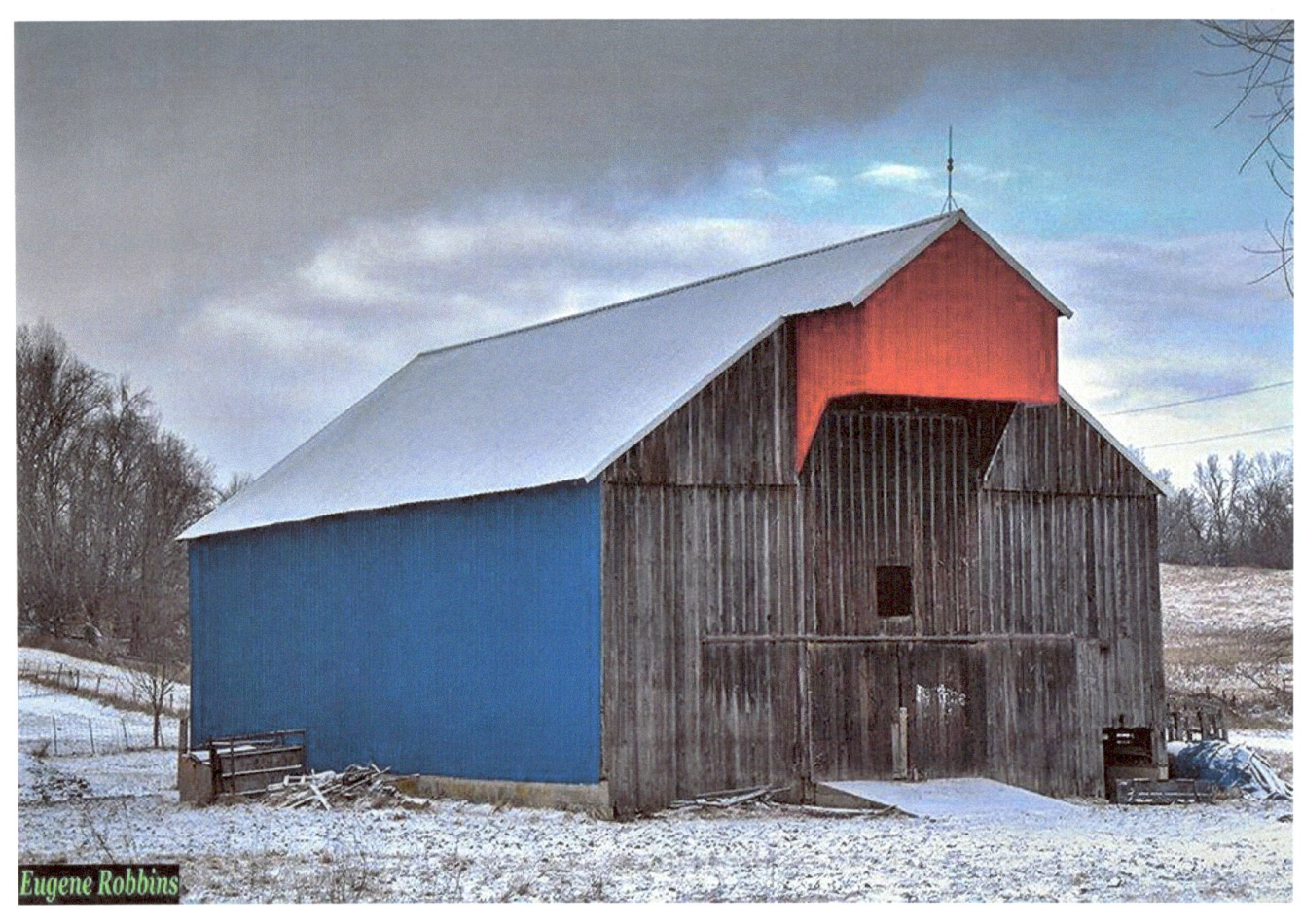

"This is a shot of the Red, White, and Blue Barn on Toler Bridge Road with a dusting of Snow".

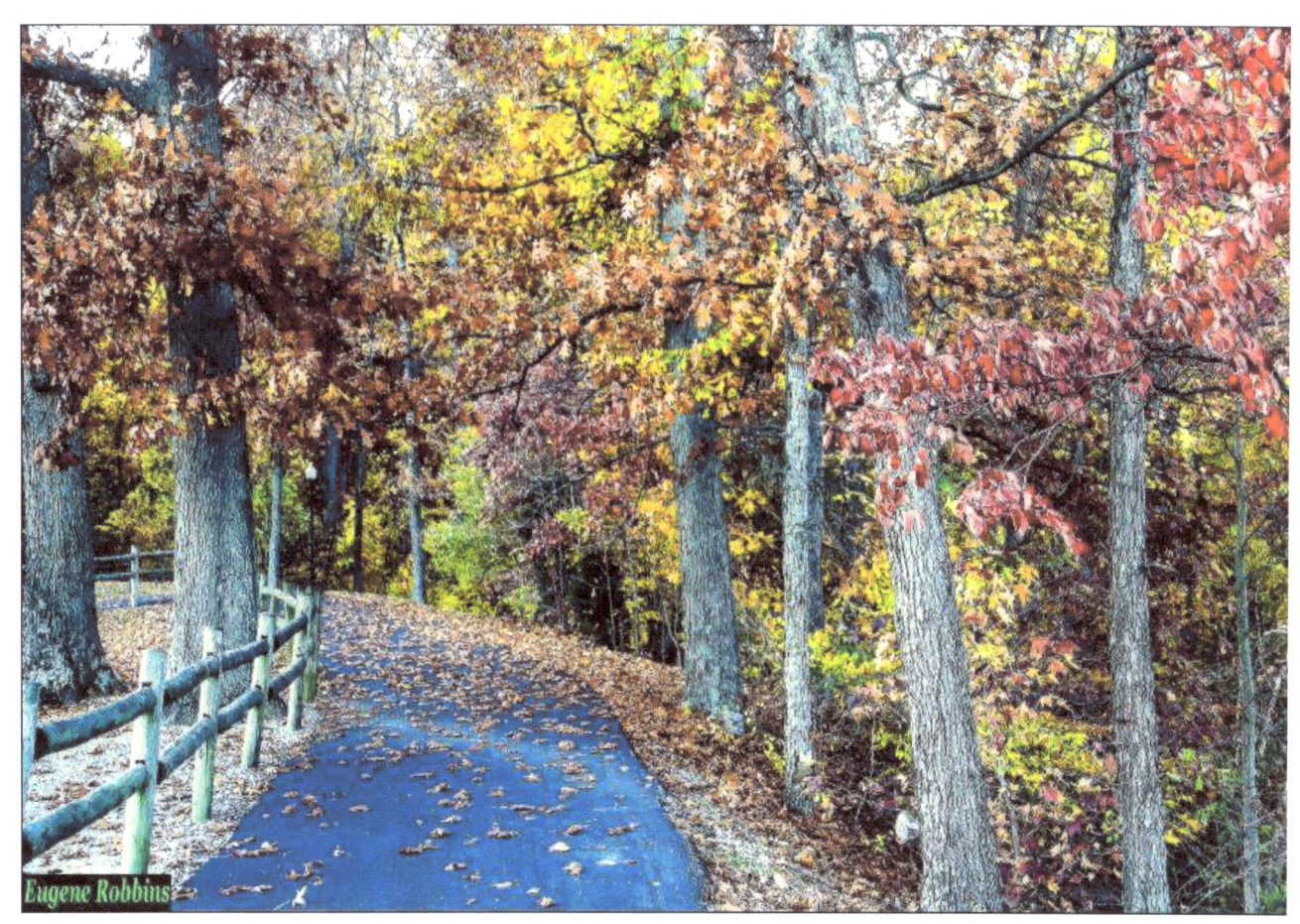

…………."the Walking Trail at Vastwood Park"……………

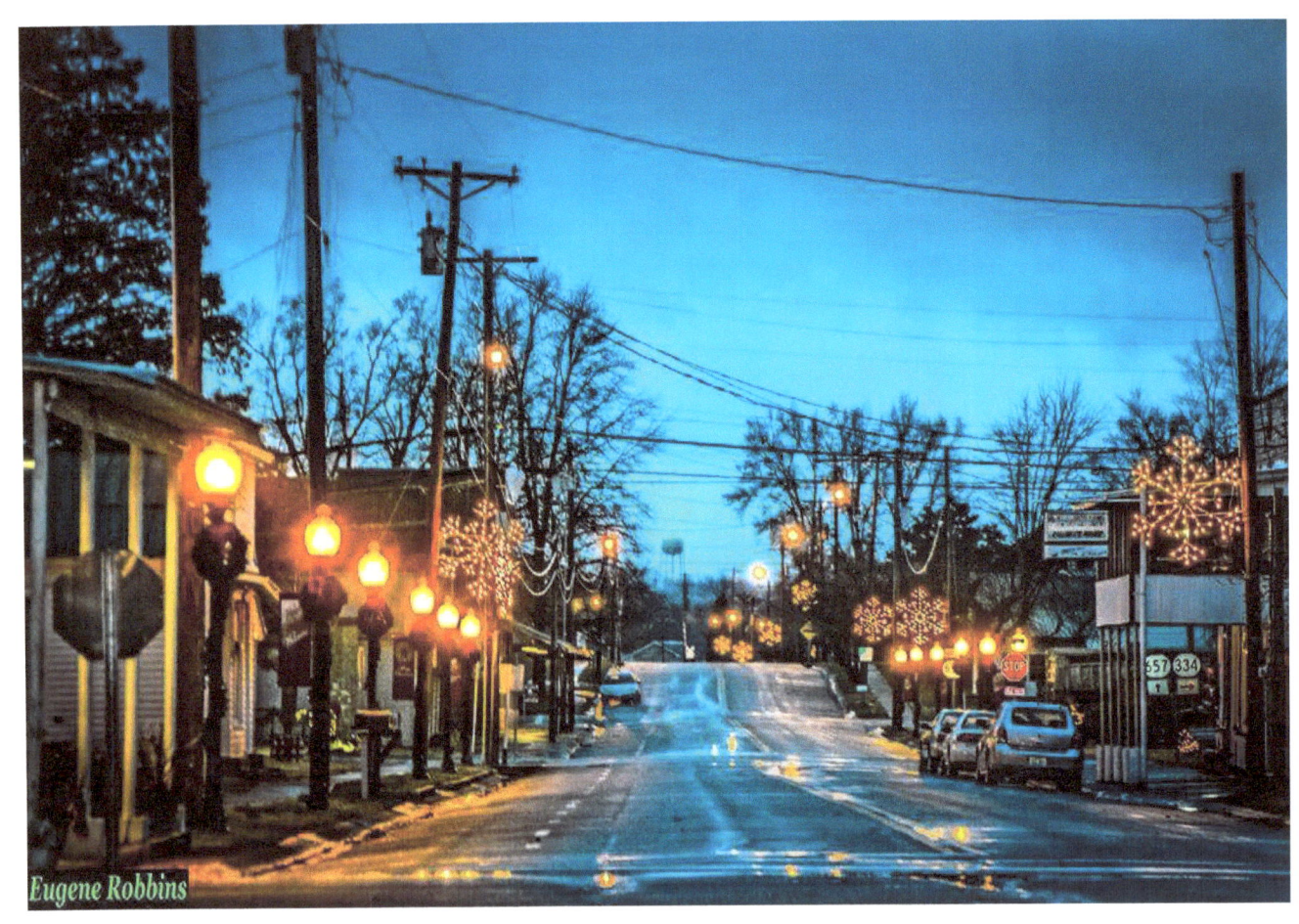

"Downtown Lewisport, Kentucky at the Holiday Season".

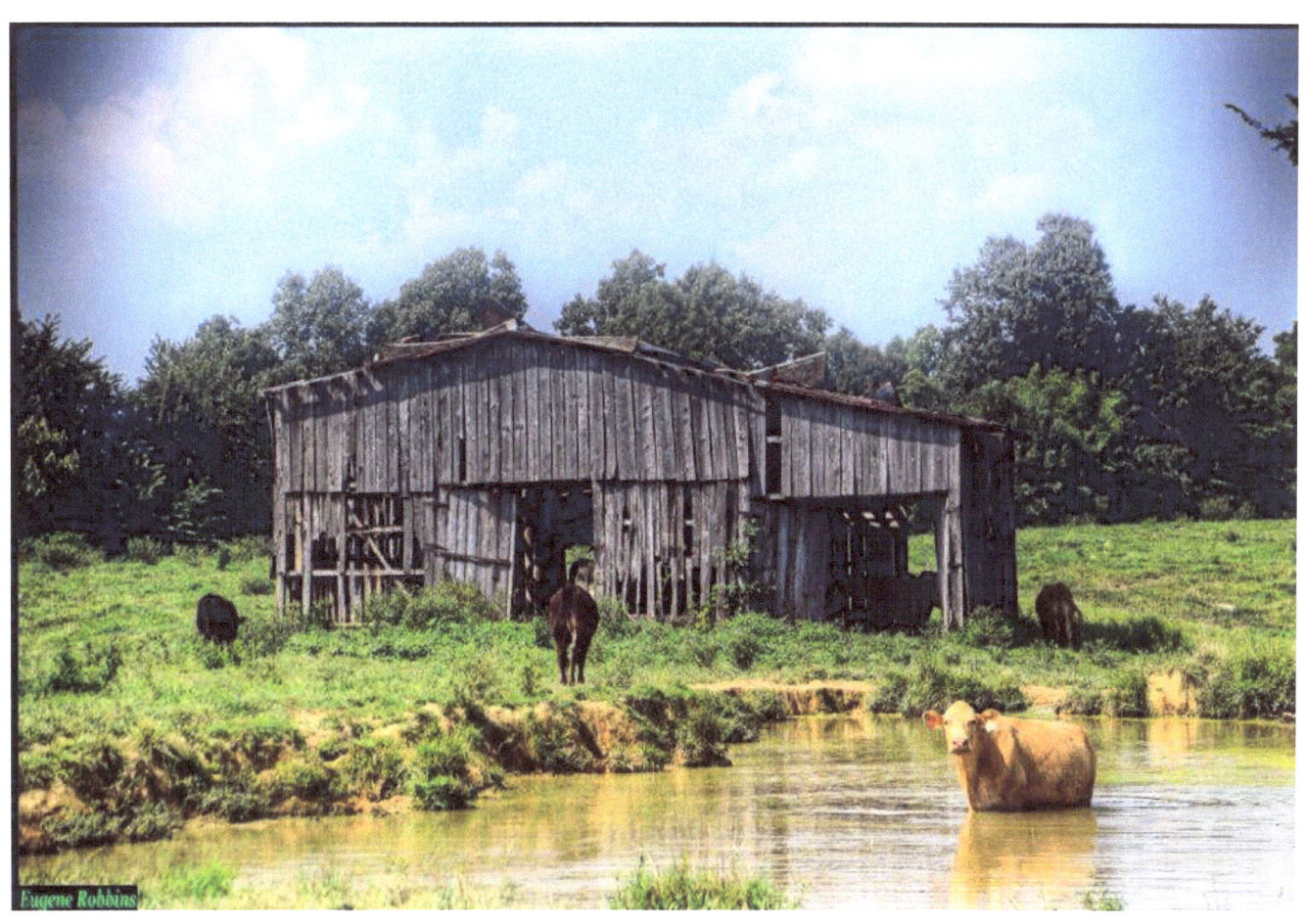

"Wild in the Country!

…….Chillin' in the Cowpool in Breck County….I didn't see a diving board and they were all Skinny dipping"…………

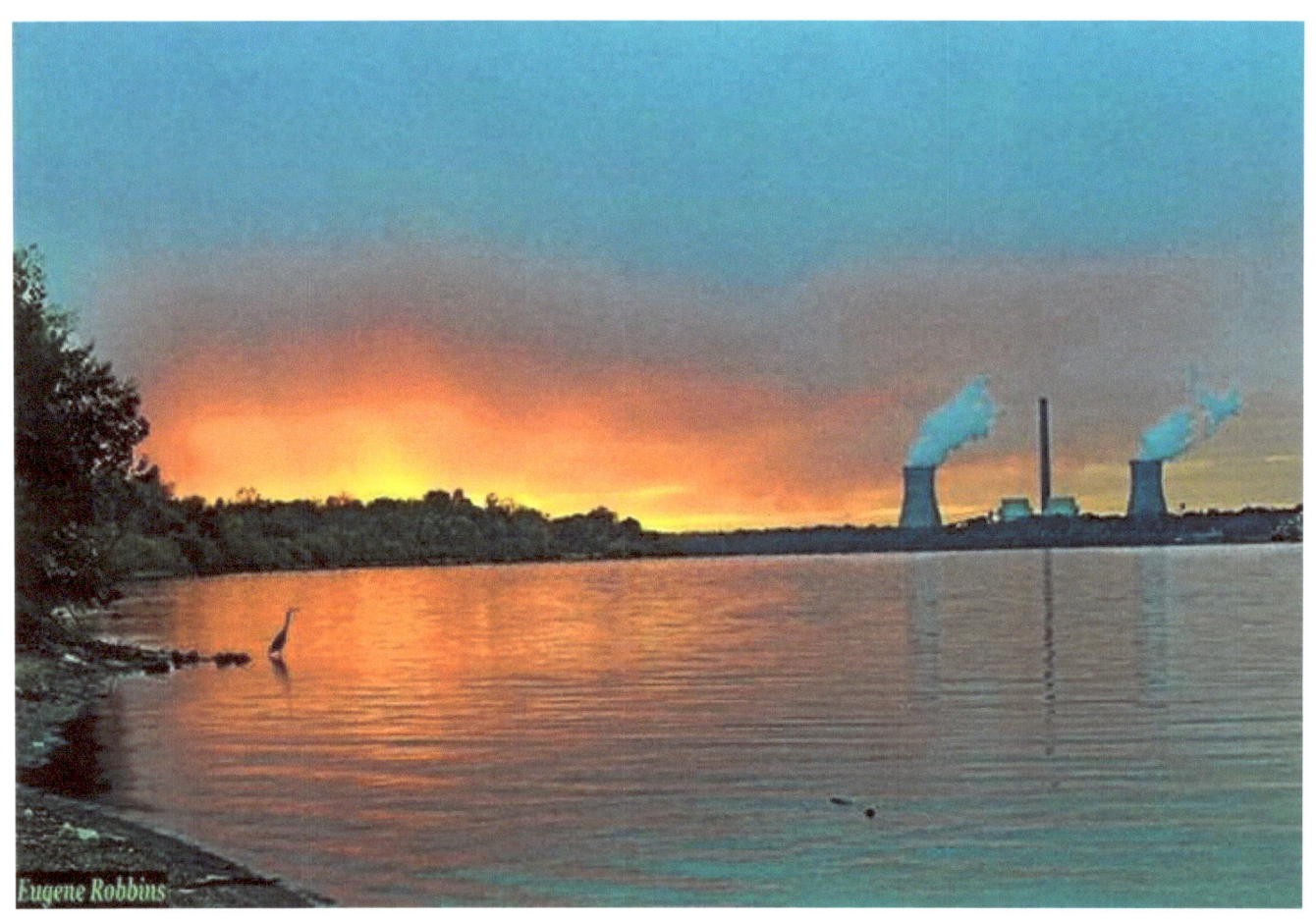

"Lewisport, Kentucky, Sunset….bought a new lens and tried it.

….see the Egret to the side on the Water".

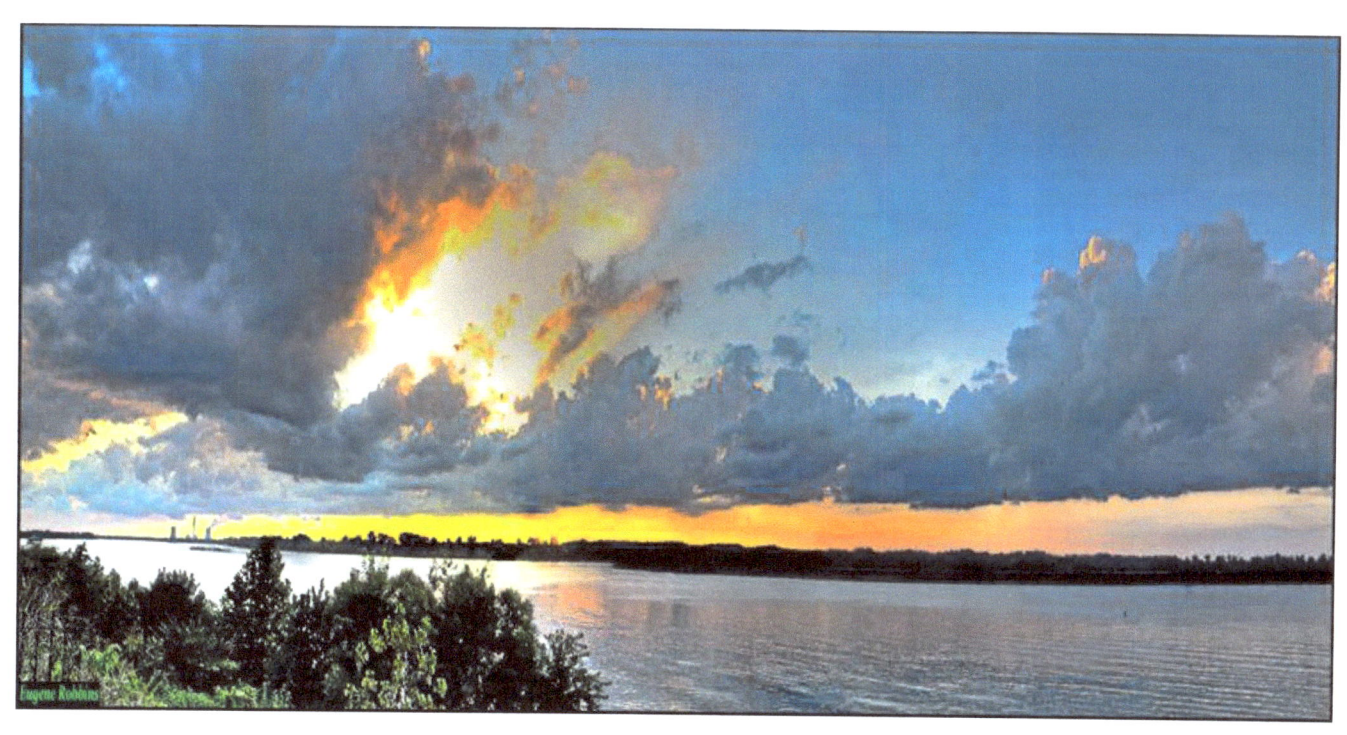

" Here is a Sunset shot from the end of 4th Street last night".

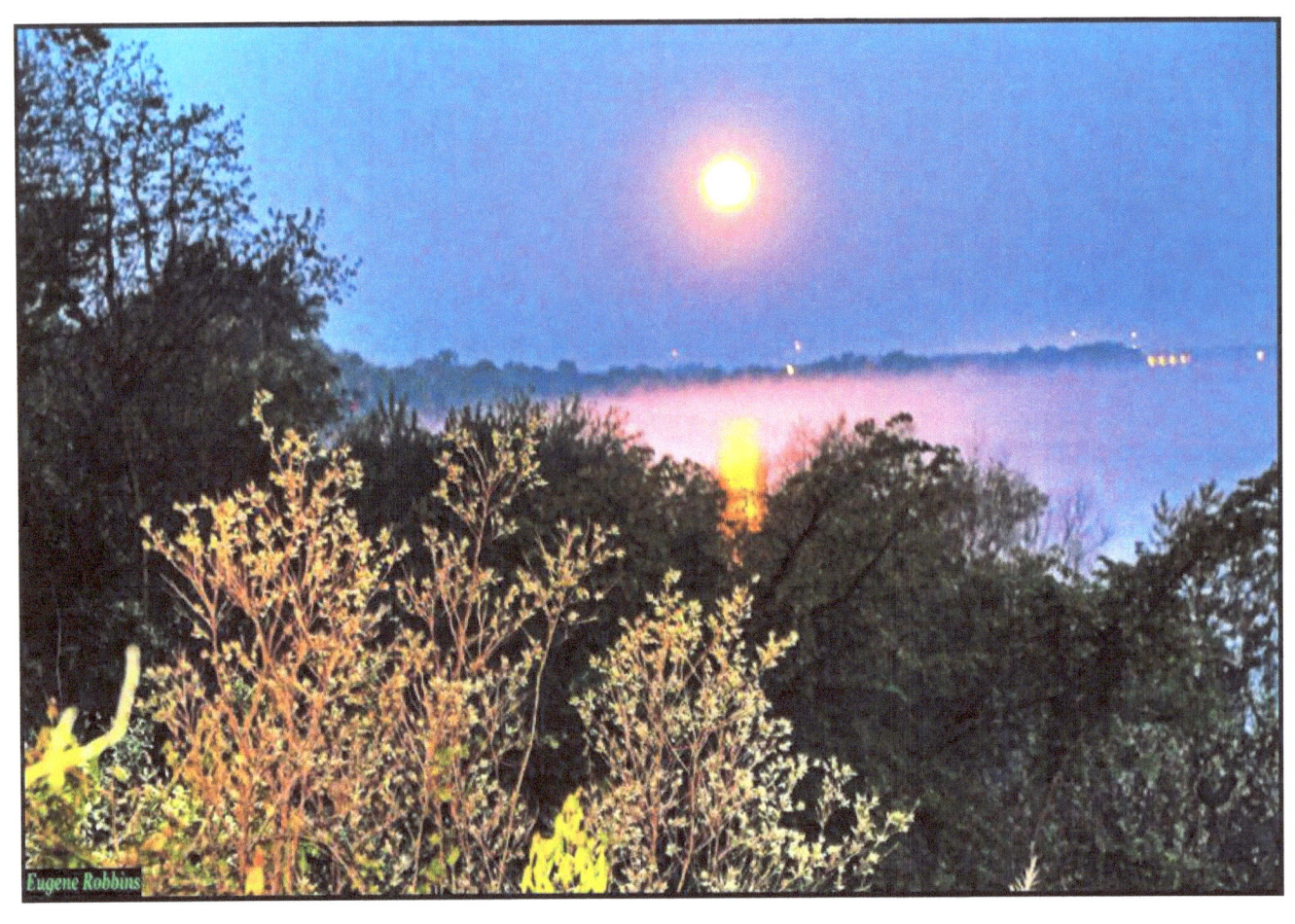

…..Good Old….." Lewisport (Kentucky) Moonshine"……..

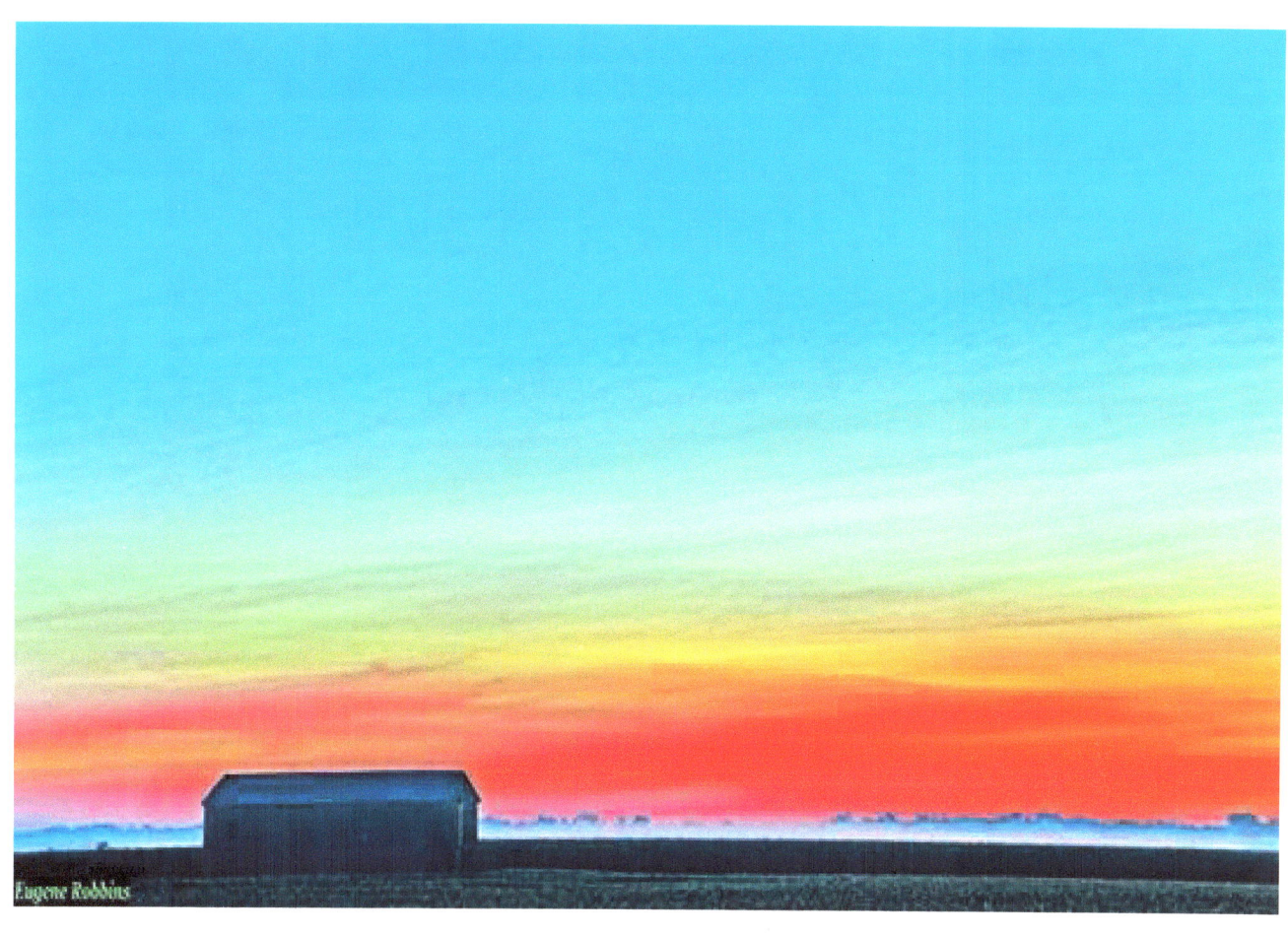

"Lewisport, Kentcky, Sunrise……..Fog was rolling on"………

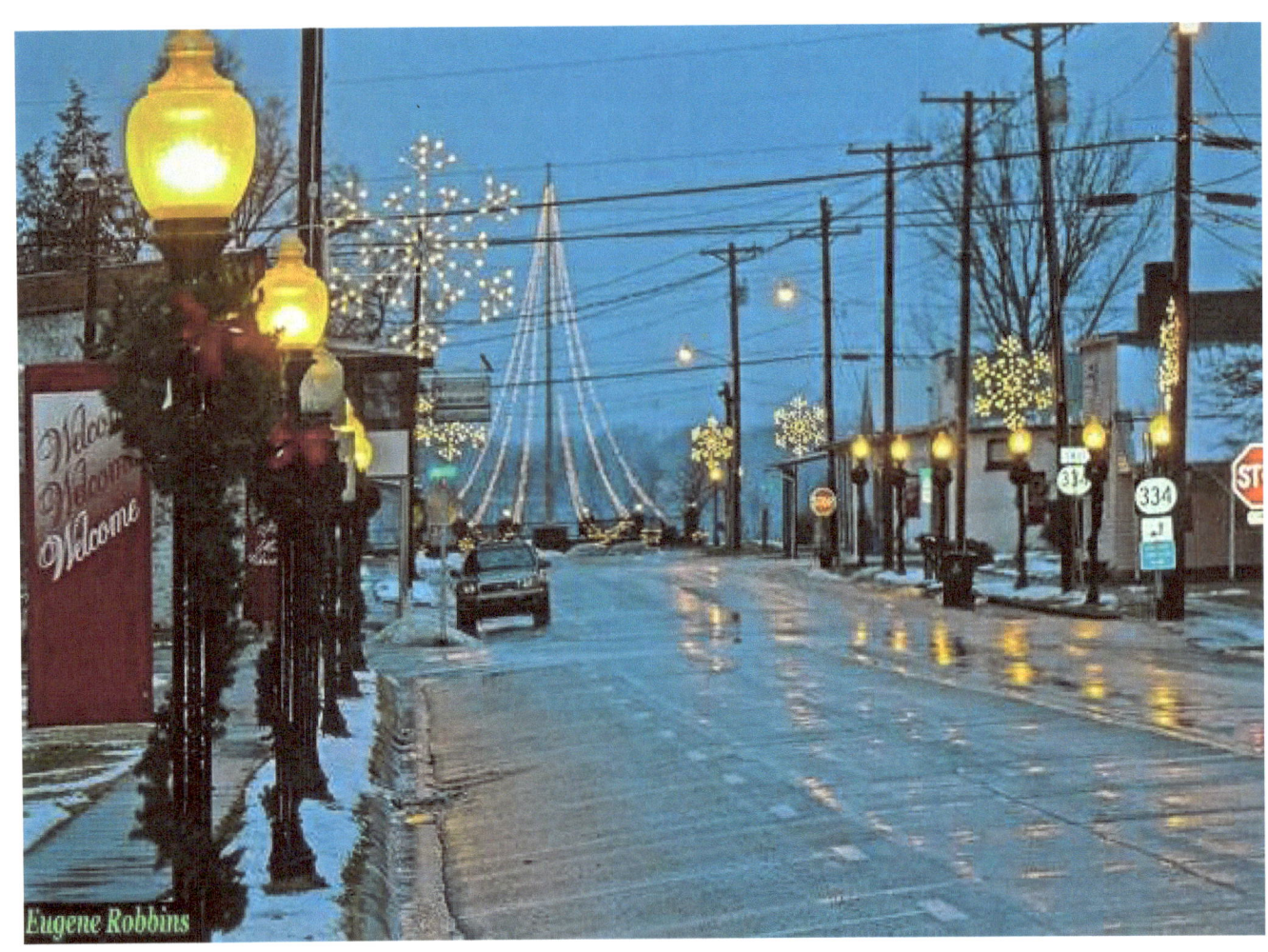

………"Holiday Season Downtown Lewisport, Kentucky"……….

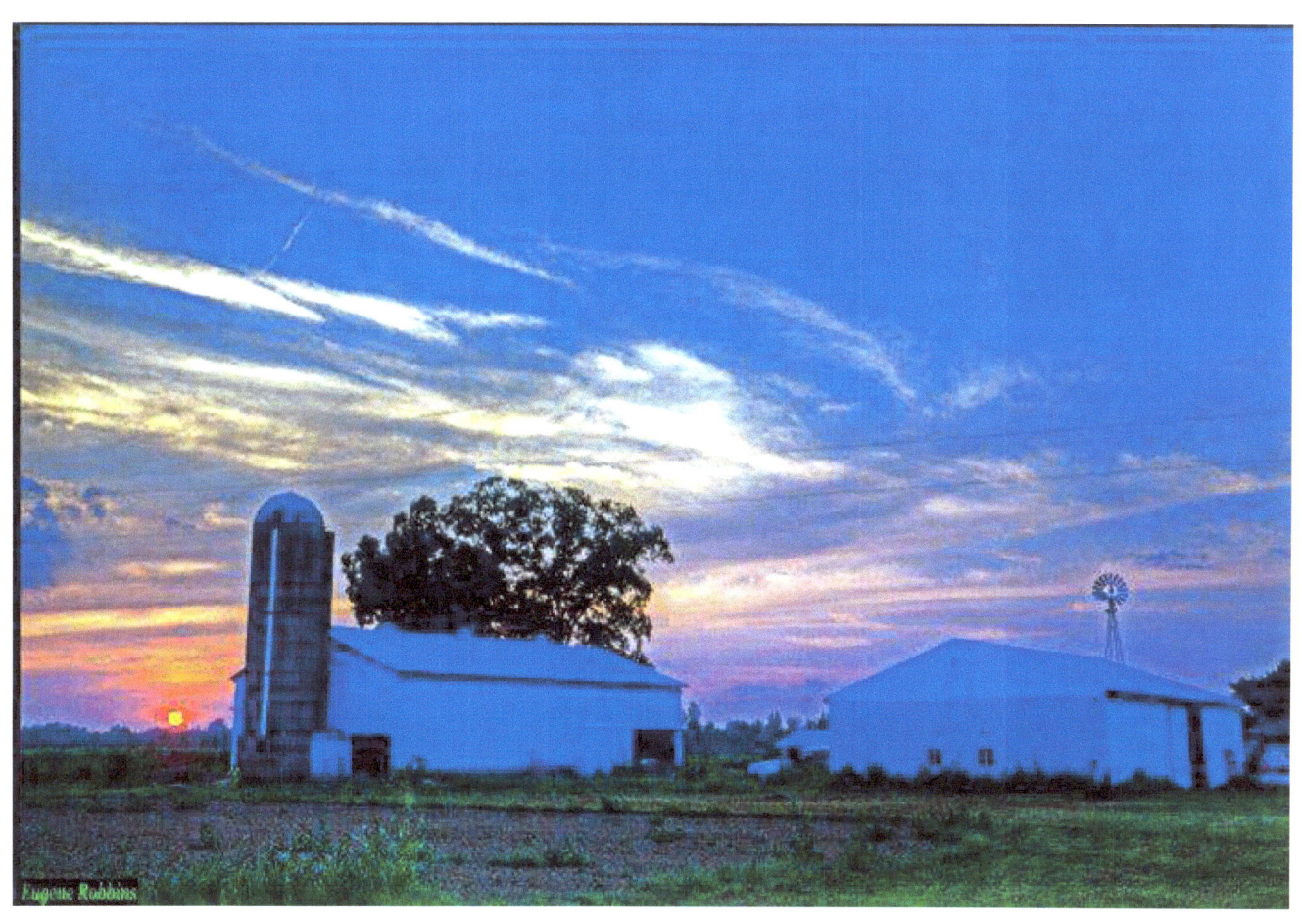

………."Sunset……at the red light in Lewisport, Kentucky"………

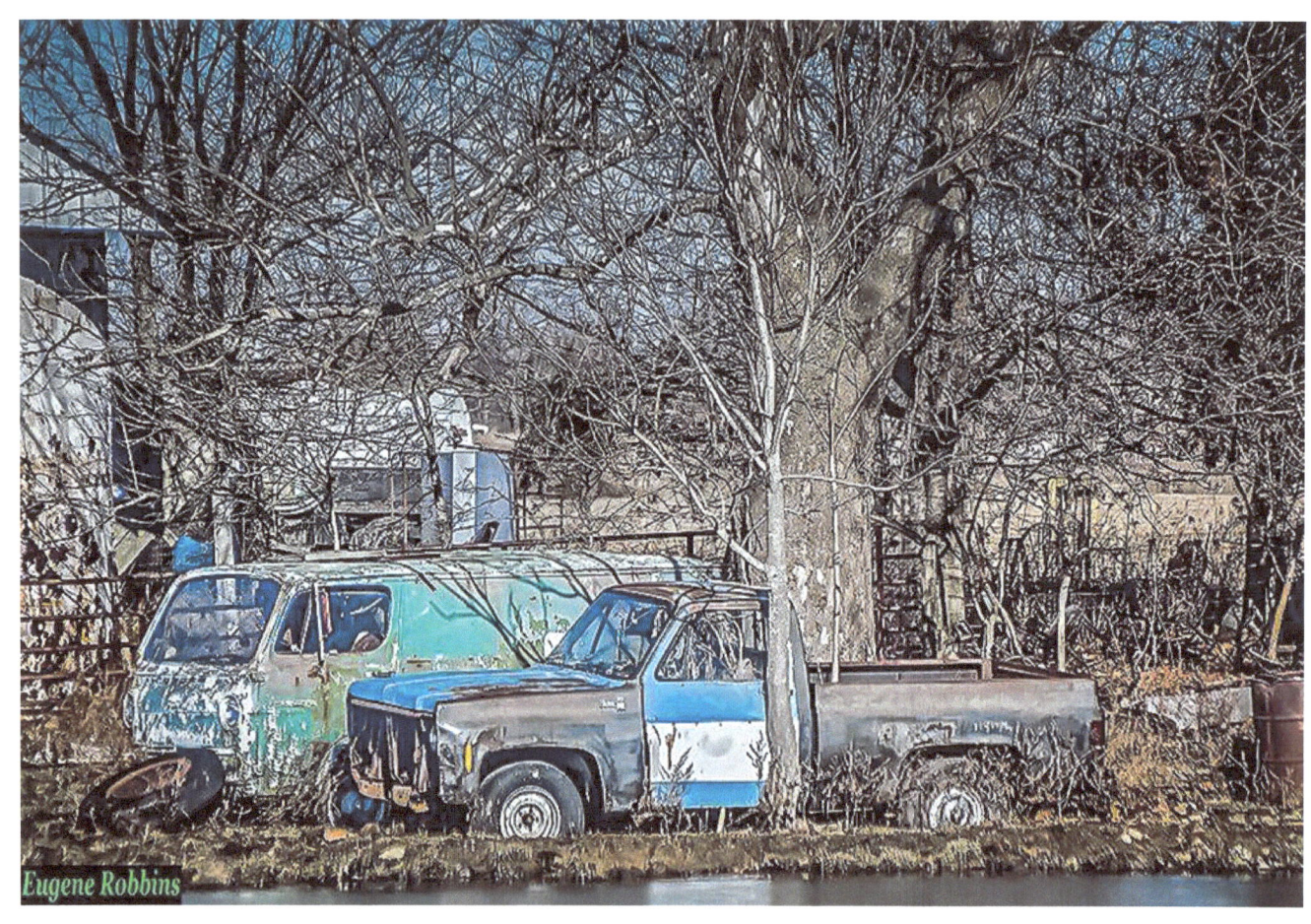

……"a car picture from Flood Roads in Breckenridge County"…….

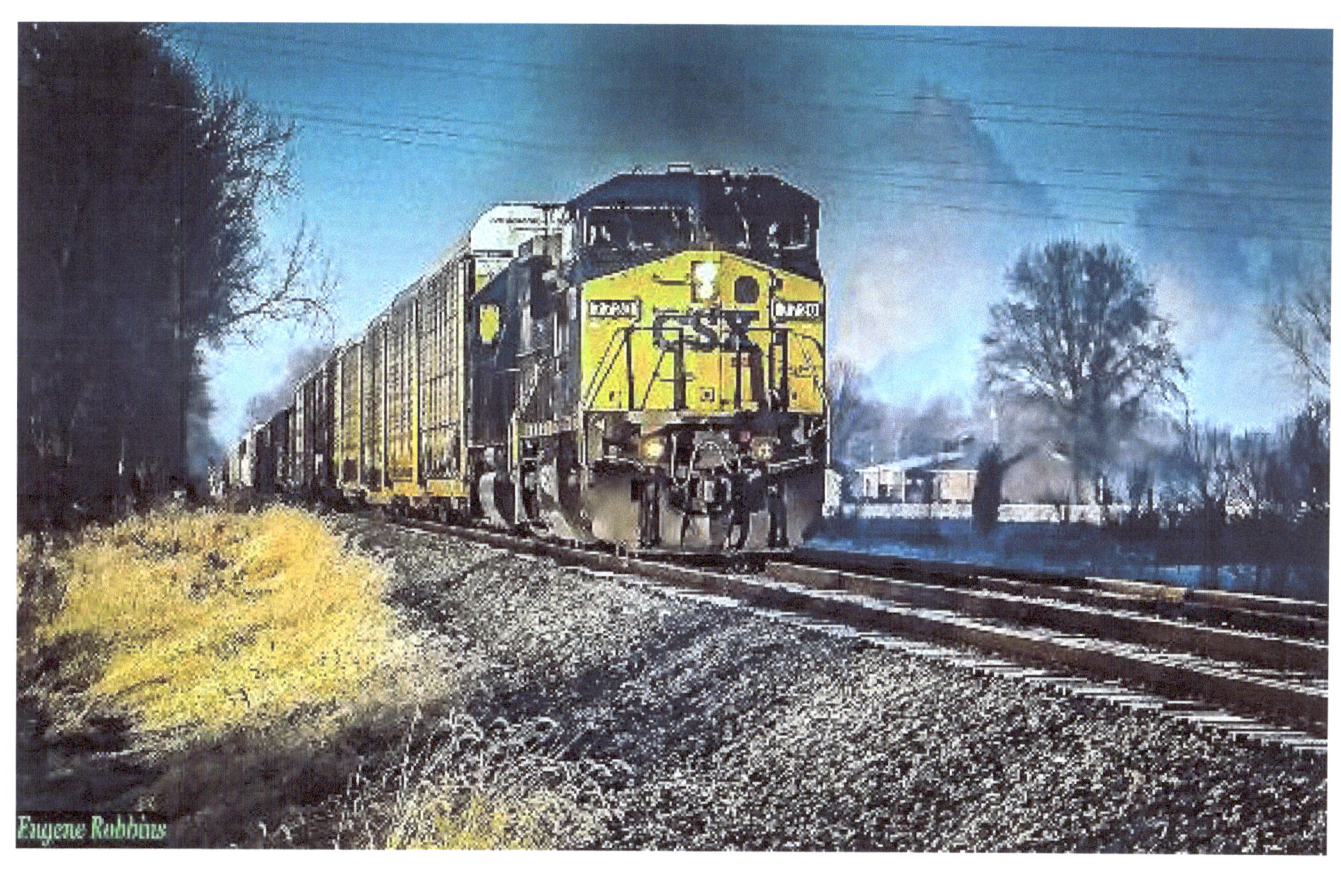

……."I heard this 'Train a Coming' and drove a piece to get ahead of it for this picture"……..

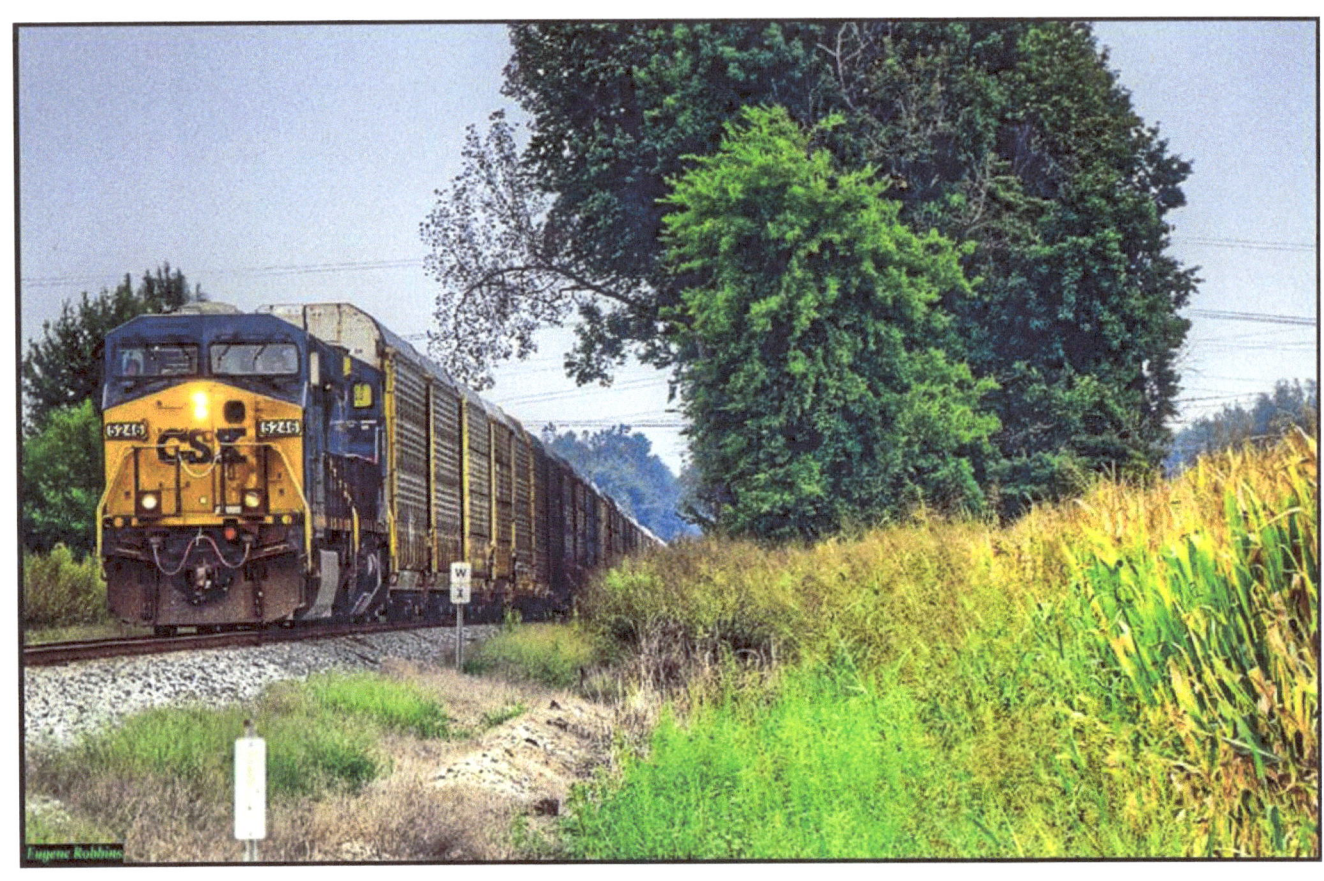

………."shot at Henderson Road just below the Airport………

…………….Lazy, Hazy Days of Summer………………..

"The start of a new Day in Lewisport, Kentucky, on Millennium Park from the rising Moon".

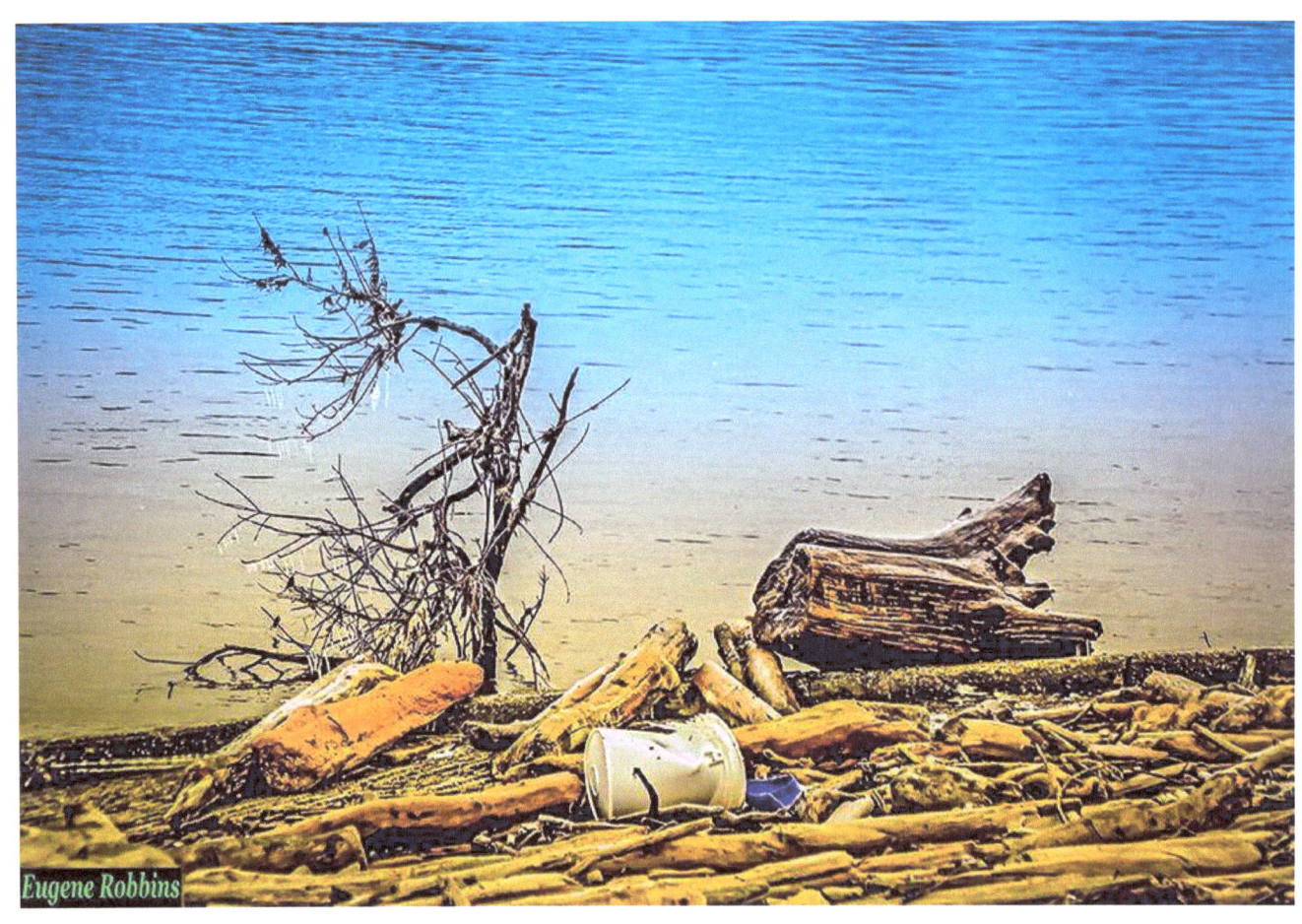

……… "Driftwood"…………

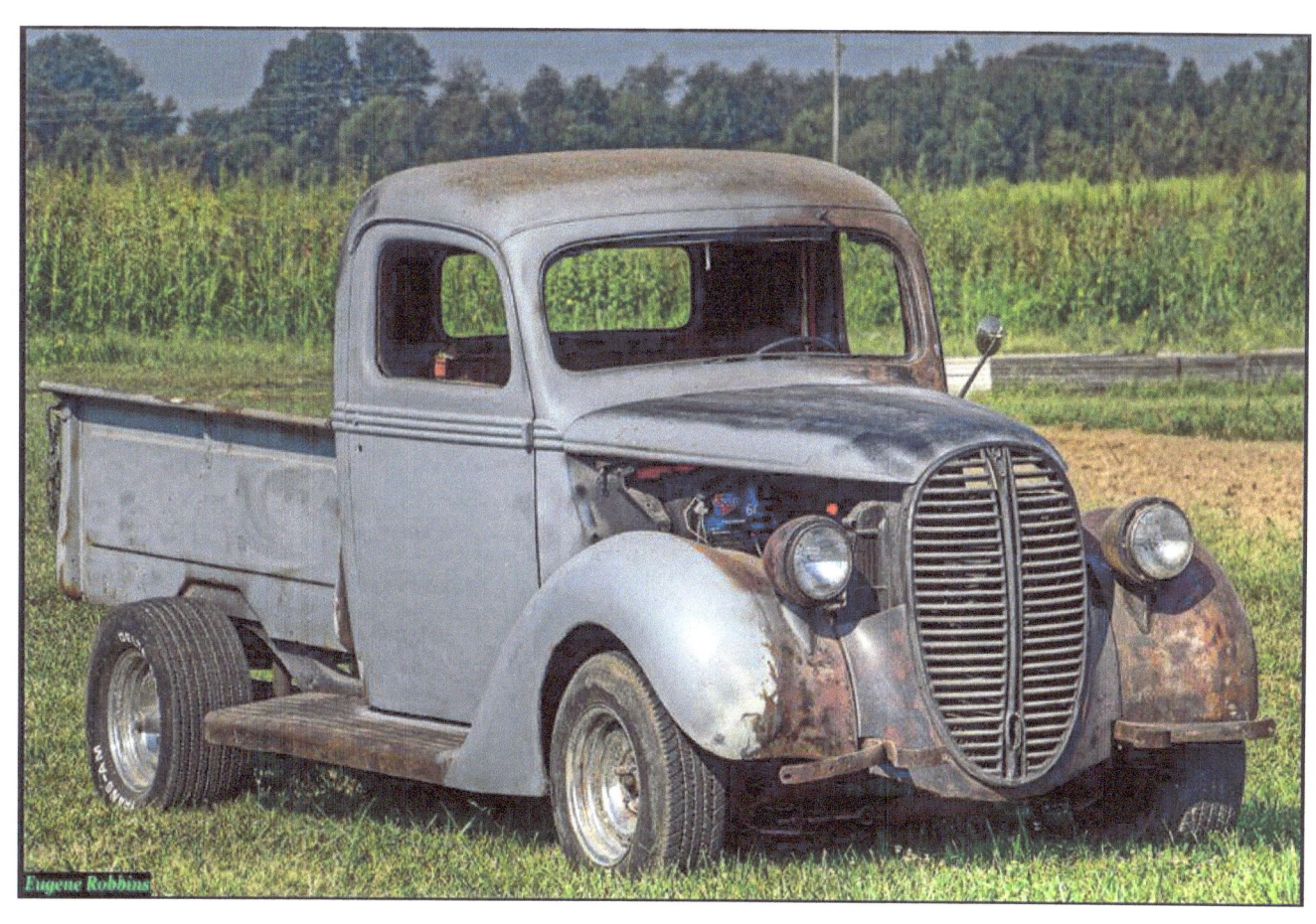

"A 1938 Ford Pickup Truck".

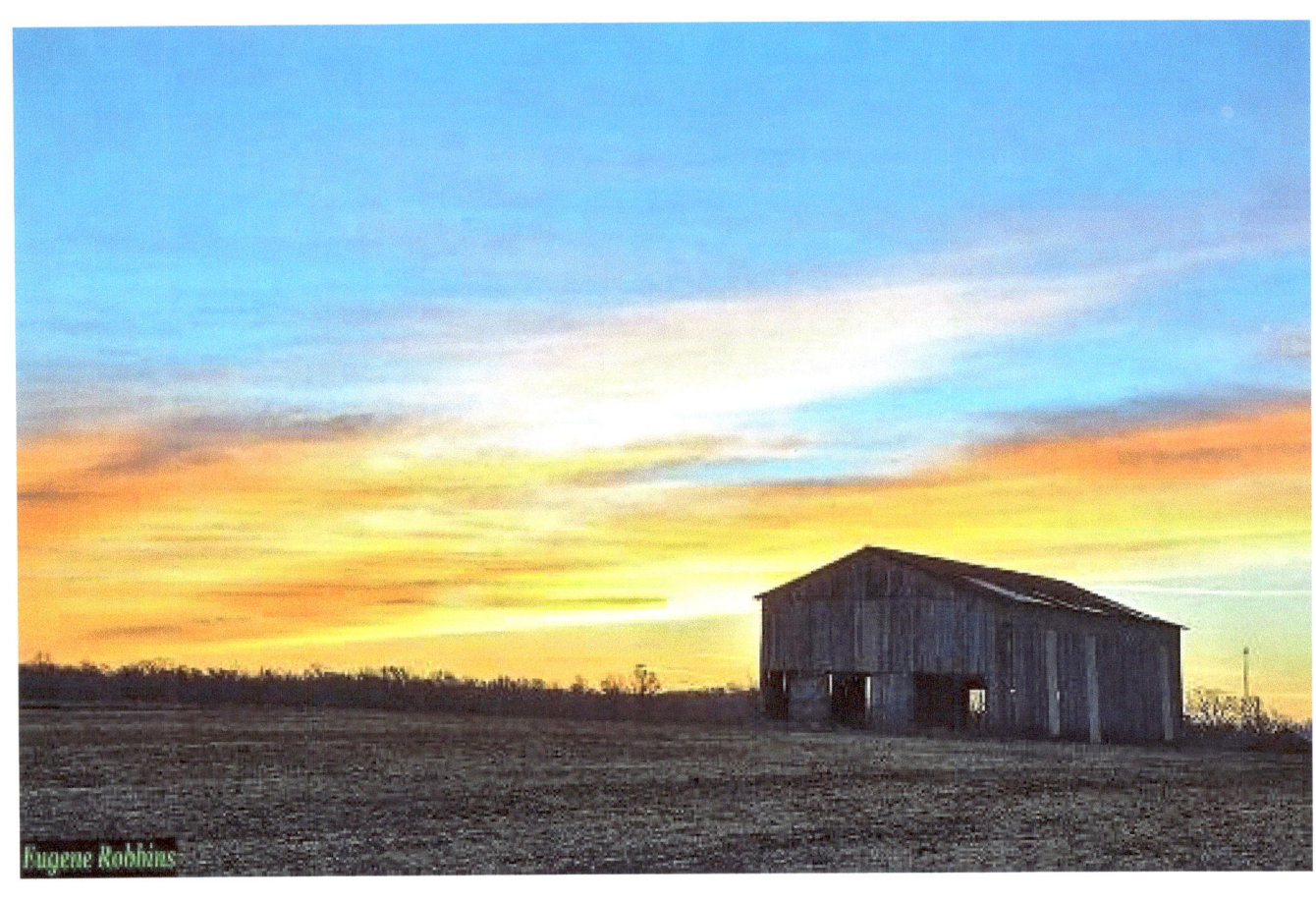

"The Sunrise is up River Road……from Hardinsburg, Kentucky".

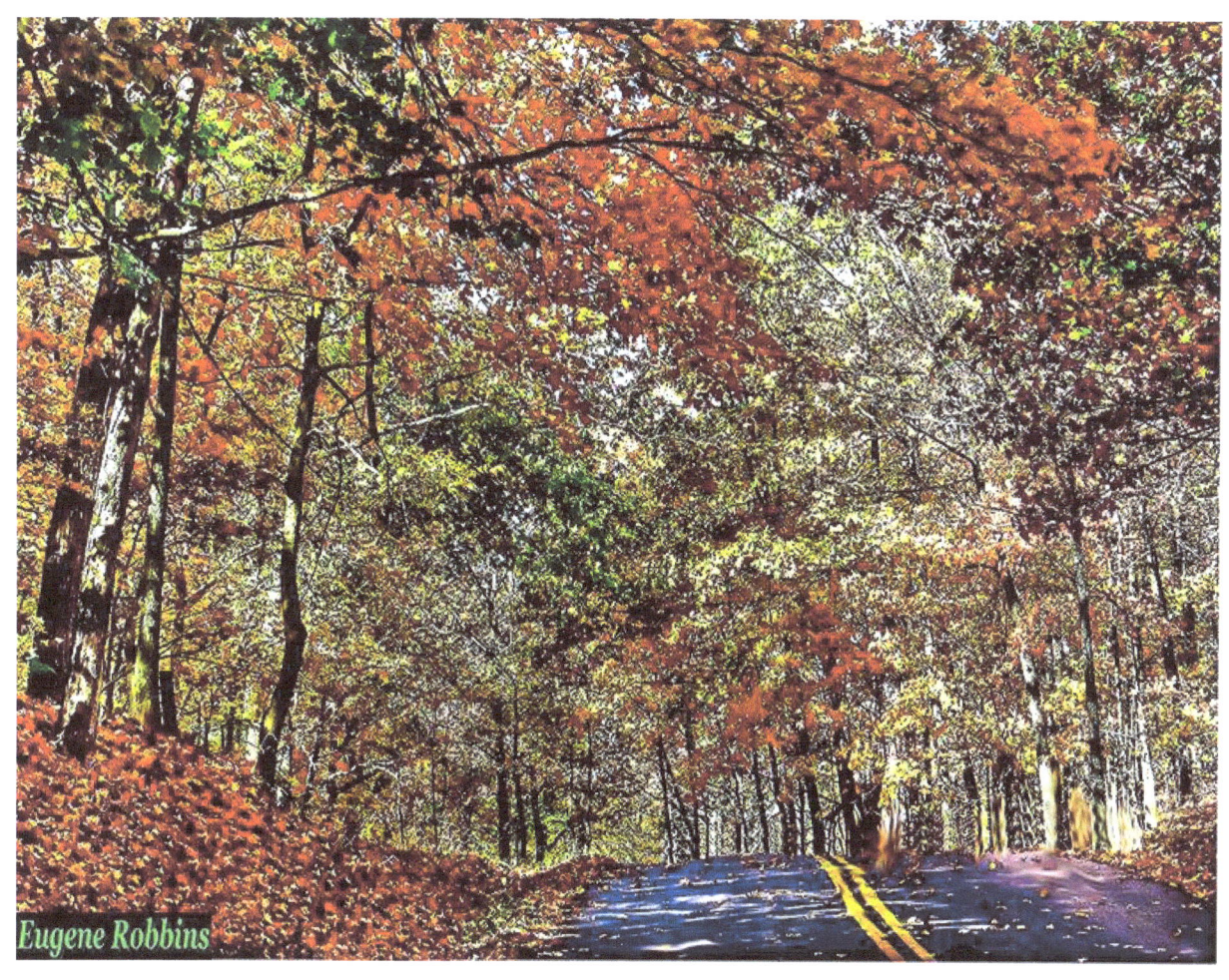

"The Fall foliage is beautiful, again, this Fall.

This was on a Country Road Southwest of Lewisport, Kentucky".

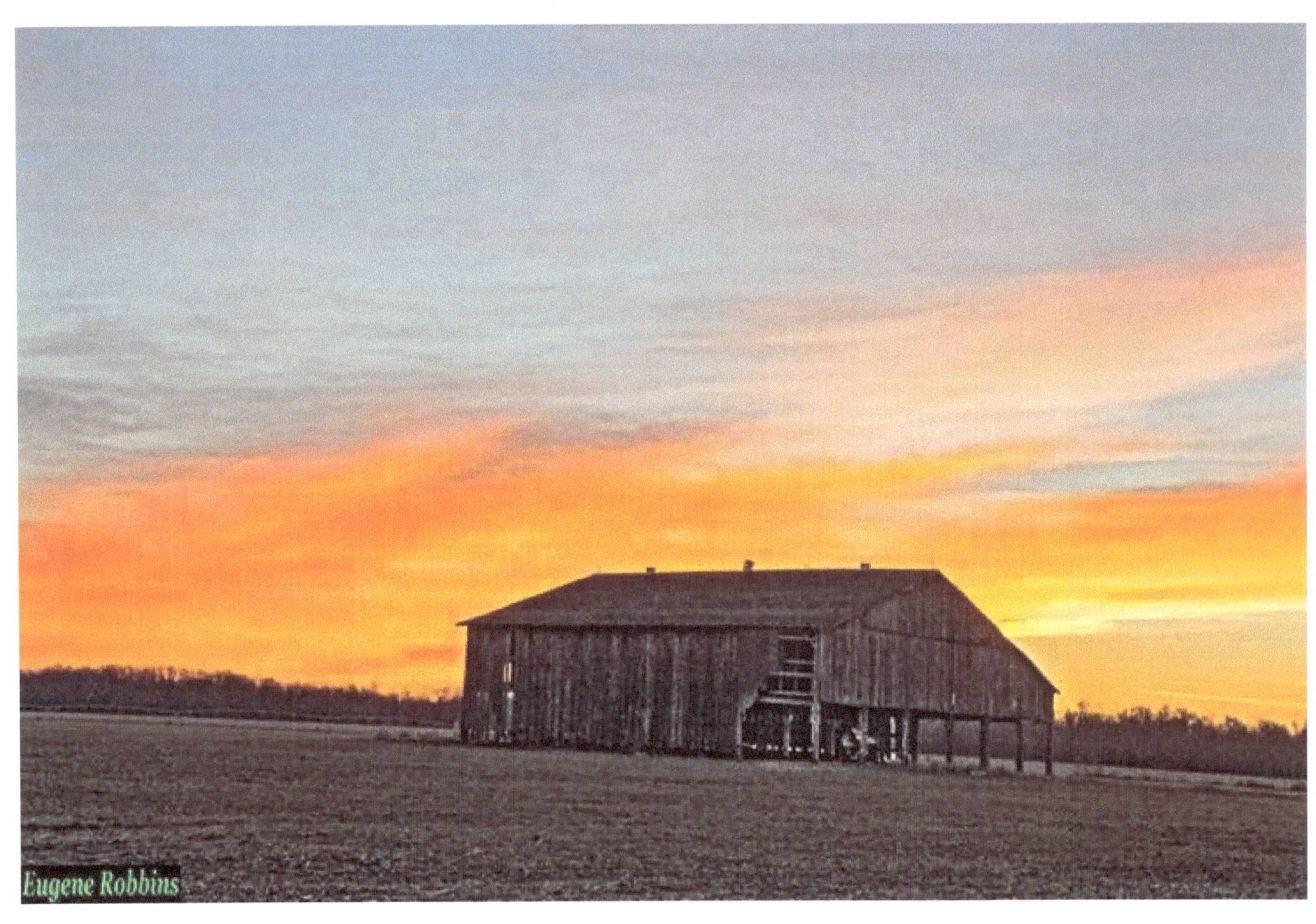

"Sunrise picture taken east of Lewisport, Kentucky, on the River Road"……..

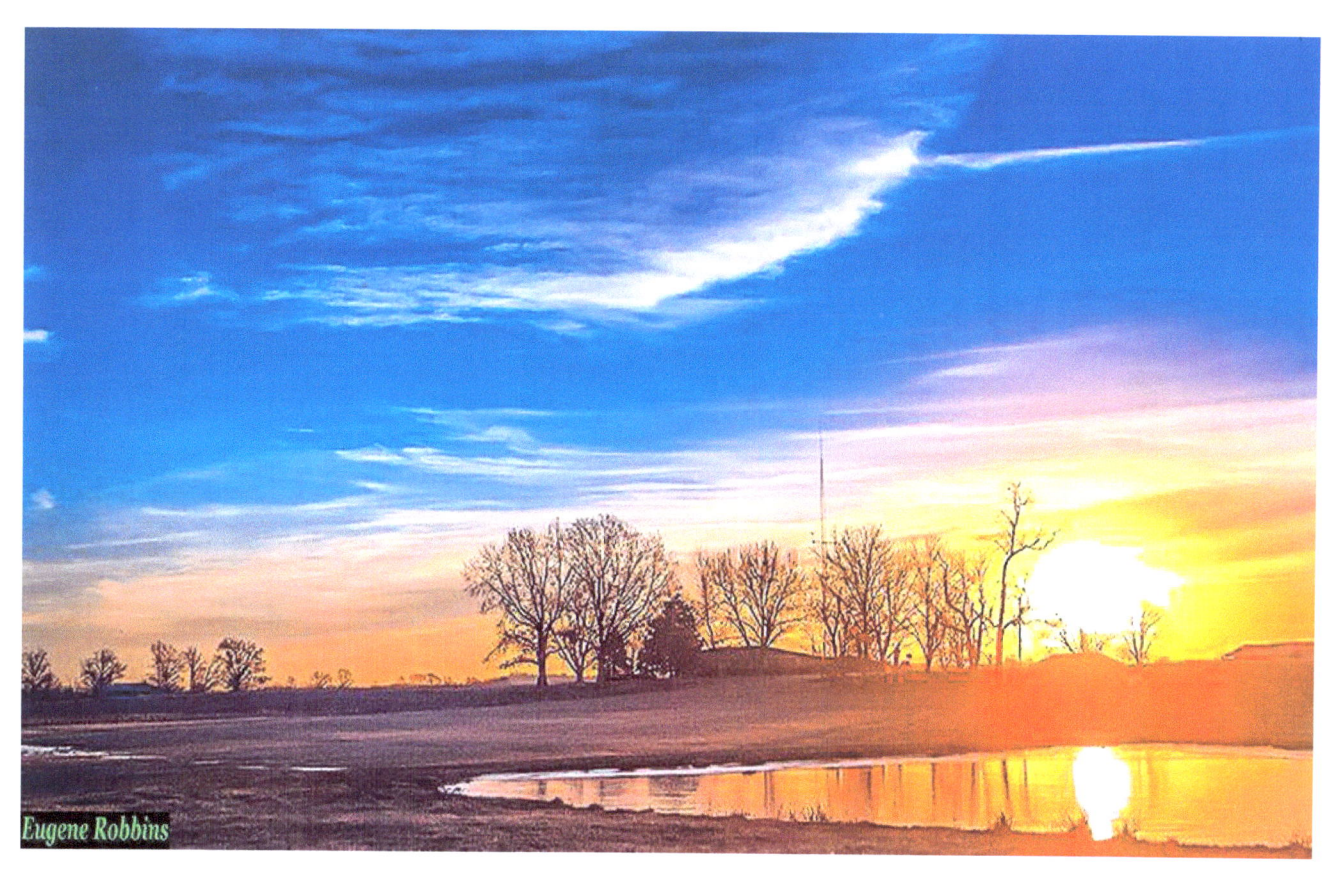

………."a Sunrise west of Lewisport, Kentucky, on HWY 334"……….

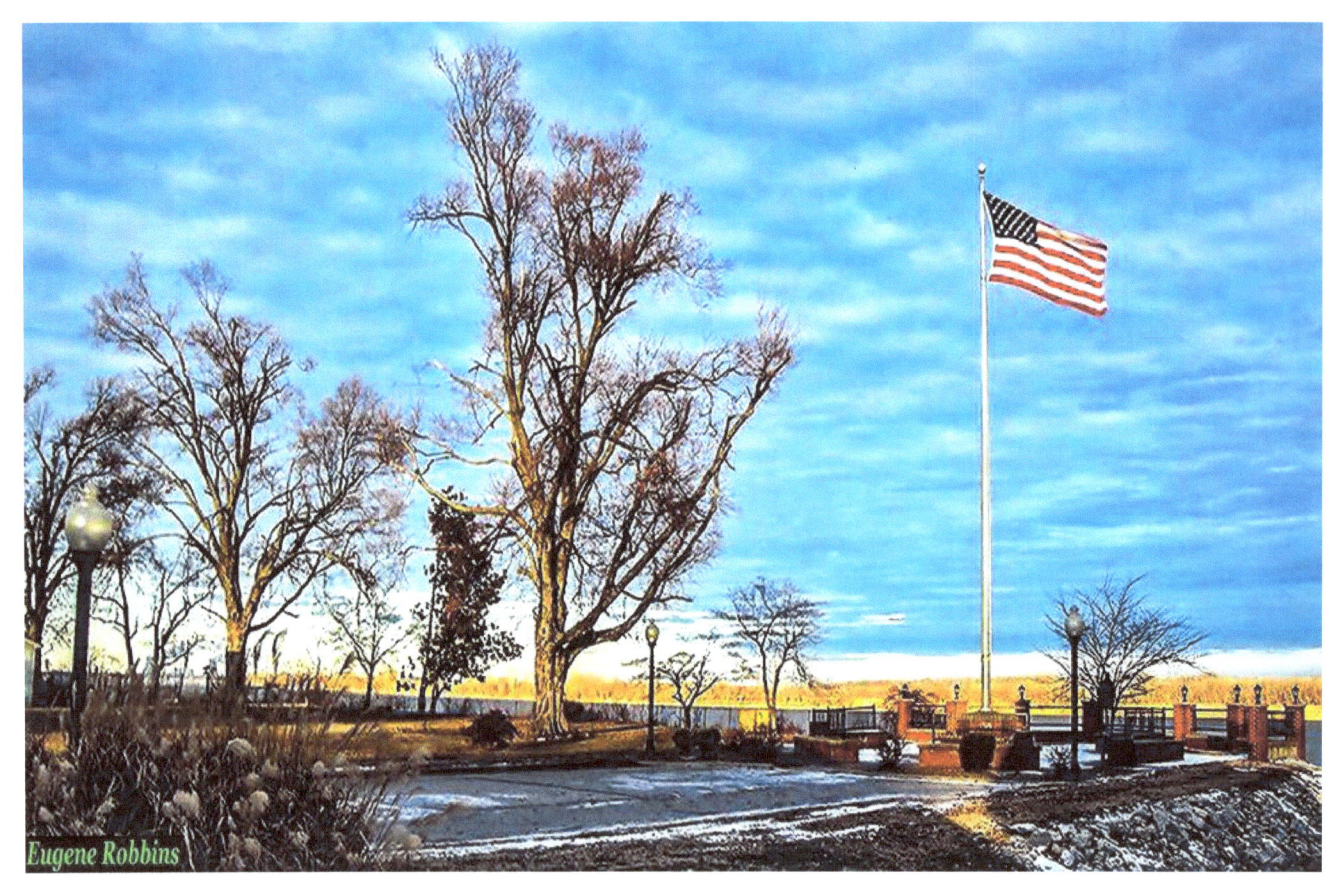

........"at Millennium Park".........

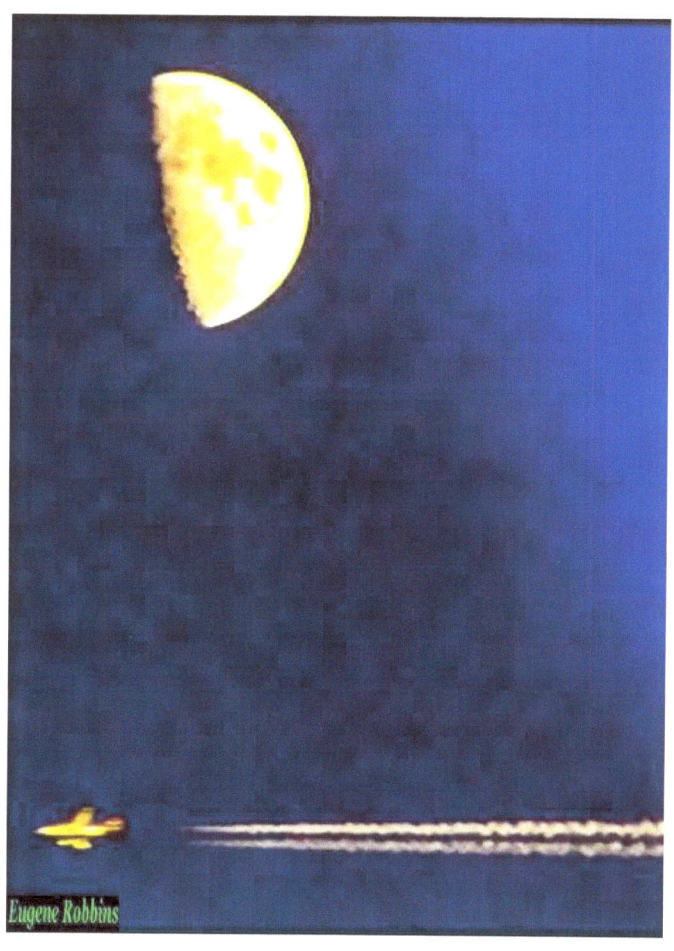

"The plane was headed straight for the moon, but, went below it instead of crashing…….the Plane is 5 inches below the Moon……… On my Computer".

www.ingramcontent.com/pod-product-compliance
Lightning Source LLC
Chambersburg PA
CBHW050810180526
45159CB00004B/1614